GOOD MORNING
Beautiful

A 40 DAY DEVOTIONAL JOURNAL

CATHLEEN GRAY

[handwritten inscription: Danisha — Live Beautifully! ♡ Cathleen Gray Ps. 27:4-5]

GOOD MORNING
Beautiful

A 40 DAY DEVOTIONAL JOURNAL

Pleasant Word
A Division of WINEPRESS PUBLISHING

Pleasant Word (a division of WinePress Publishing, PO Box 428, Enumclaw, WA 98022) functions only as book publisher. As such, the ultimate design, content, editorial accuracy, and views expressed or implied in this work are those of the author.

Unless otherwise noted, Scripture quotations in this book are taken from the New King James Version, © 1979, 1980, 1982 by Thomas Nelson, Inc., Publishers. Used by permission.

ISBN 1-4141-0675-0
Library of Congress Catalog Card Number: 2006900104

DEDICATION

I dedicate this book to my gentle and caring husband who wrote on an index card these words, "Good Morning Beautiful! I love you, Hannah loves you and God loves you!" It was this simple, yet profound note that propelled me to take a good look at myself from the perspective of my husband, my daughter and most importantly, my God. I still have that note card with its smudged black print from my tears on it as a wonderful reminder of where I was, and where I am headed. I thank God that he gave my husband the insight to write that note, knowing that it would be a struggle for me to get out of bed and make an attempt at functioning that day.

It is my prayer that God's holy and inspired Word will strengthen and encourage you, just as it has strengthened and encouraged me. I pray that what I have experienced through the study and application of the Bible will bless and comfort you.

So I say to you, "Good Morning Beautiful! I Love You, Your Family Loves You, and Most of All . . . God Loves You!"

TABLE OF CONTENTS

WITNESS

"You are my witnesses," says the Lord, "And my servant whom I have chosen, that you may know and believe me, and understand that I am he...."

(Isa. 43:10)

Upon beginning this incredible journey to fulfill God's call on my life to minister to women, I read this scripture, meditated upon it, and took it in as my own. I know that this scripture was written just for me, and I still use it today as my personal mantra.

When I was going through the healing process from the effects of my past, I dealt with extreme emotions and overwhelming pain. In the midst of complete devastation, I came to a place in my life where I was trying to figure out the why's and how's of sin. I wondered why I chose the path that I did, and how I got so far off course. I wondered why I felt so awful and how I could learn to move on. I asked God why I was going through this suffering and how come it had to hurt so badly. I asked him to show me why I did what I did and how I could heal from the consequence of my transgressions.

Father God, in his amazing and gentle way, revealed to my heart that through all of this I would know GRACE. It was then that the light went on. I began to fully understand the incredible grace that was given to me on that cross where Jesus Christ, the Savior of the world, hung. It was then that I began to fully understand my need for grace, and all the riches that go along with it. It was then that I completely understood that my life is a living testimony to the outpouring of this grace—and that I had to share my life's lessons with you.

I know without a doubt that I am one of God's witnesses because of what he has done for me, through me, and to me. My sins are great and they are many, but they are no match to the only One who has the power to totally and completely remove them as far as "the east is to the west." I know without a doubt that I am his servant and he has selected me because I had no other option but to believe him. And in that believing I understand he is God. I also know without a doubt that he has chosen you to be his witness to the power of his grace. Will you join me in rediscovering who you are in him through his grace? He thinks you are beautiful and he wants to create within you a renewed life worth living. It is time to wake up, for it is a new day. Good Morning Beautiful!

> Through the Lord's mercies we are not consumed, because his compassions fail not. They are new every morning; Great is your faithfulness. "The Lord is my portion," says my soul, "Therefore I hope in him!"
>
> (Lam. 3:22-24)

> Then he who sat on the throne said, "Behold, I make all things new." And he said to me, "Write, for these words are true and faithful."
>
> (Rev. 21:5)

SOMETHING TO THINK ABOUT...

The word "witness" means to observe, to report, and to give testimony. Being a witness is an extremely important aspect of our society's judicial system. A clear and precise witness can be the difference between life and death, imprisonment or freedom. Leviticus 5:1 says that if a person has seen or known of the matter in question and does not tell, then they bear guilt. So the witness has a responsibility—not only to the court, but also to himself or herself.

Likewise, we are called and commanded to be a witness for Jesus Christ. We are to observe his Word by studying and living out the Bible. We are to report on what he has done in our lives by telling and showing others. And we are to give testimony about God the Father, God the Son, and God the Holy Spirit.

Think of your life right now. What is your "witness" like? Would God say that you are one of his chosen witnesses? Have you believed and understood that he is God? Do you share with others who he is in your life when the opportunity arises? Or do you bear guilt because you have seen his mercy and have not told others about it?

In the space provided, plead your case.

JESUS SAVES

⌇

Blessed be the God and Father of our Lord Jesus Christ, who has blessed us with every spiritual blessing in the heavenly places in Christ....

(Eph. 1:3)

Gently reflect on your life before you accepted Christ as your Lord and Savior. Is your life drastically different? Are you totally and radically changed? If not, do you want to be? When our great and mighty Creator took upon himself human form in the being of Jesus Christ, he did so with a great and mighty purpose.

God is so holy and awesome that we humans, with our sinful nature, cannot be in the presence of the Most High. But God, with his infinite and limitless power and love, created for us a beautiful and simple way to be a part of who he is by the gift of Jesus Christ. It is because of Christ that we can have full access to God. Jesus willingly suffered and painfully died as our sacrifice, and miraculously rose from the dead so that we wouldn't have to endure eternal punishment for our sinful nature. Not only that, but Jesus lived as a sinless man on earth as our fellow brother

to show us the example of how to live our lives in service and love toward one another.

If you really want to know WWJD (what would Jesus do), don't just wear the bracelet. Read your Bible and find out what Jesus actually did! In addition to all the wonderful things Christ did for us, he gave his Holy Spirit to live and dwell within us to be our guide and comfort. Upon his acceptance in our lives, we are blessed with every spiritual blessing in the heavenly places. We are now in Christ. We are eternally secured in him. Nothing can change this. Not our past, because it has been completely forgiven and forgotten by God. Not our present, because God loves to change us, teach us and mold us. Not our future, because he has given us a future and a hope. Not even the devil can change that, because we have been sealed with the Holy Spirit. Greater is Christ in us than the devil in this world. We as Christians are so blessed, because no matter where we are spiritually, the benefits are there. All that Christ has done for us is unchanging, and his promises are eternal.

The first part of Ephesians says that he has predestined us to adoption, freely bestowed his grace, redeemed us through his blood, forgiven us completely, made known the mystery of his will, seated us with him in heavenly places, brought us near by the blood of Jesus, and reconciled us by the cross. Here are our benefits: we have obtained an inheritance, we are sealed in the Holy Spirit of promise, we are the fullness of him, we have access to the Father, and we have boldness and confidence. The promises go on throughout the Word of God.

Sister, we have been given all this through salvation! God says that he is a shield around you and he is the lifter of your head. Look to him. Pray to him. Love him. With Christ you are never alone. There are no surprises with him because he is all knowing. You don't have to fear any longer, because you have extreme value and are worth so much to him. You have no reason to doubt because he promises that he will never leave

you or forsake you. You have no reason to worry because God is on your side, and Jesus is continually standing up for you. He loves you and he delights in you. So keep going and know you are his, because Jesus saves!

> Therefore he is also able to save to the uttermost those who come to God through him, since he always lives to make intercession for them.
>
> (Heb. 7:25)

> I have been crucified with Christ; it is no longer I who live, but Christ lives in me; and the life which I now live in the flesh I live by faith in the Son of God, who loved me and gave himself for me.
>
> (Gal. 2:20)

SOMETHING TO THINK ABOUT...

Salvation. Are you truly born again? Have you given your life to Christ? If not, then now is the time. Invite Christ into your heart. Ask him to save you from an eternity without him. Pray that he changes you completely. There is no magical prayer or ceremony; just be honest and real. Do you want to live for God forever? The choice is yours. Jesus saves!

Write about your own spiritual journey, beginning with your first realization of God and his love for you.

PROMISE

Therefore let that abide in you which you heard from the beginning. If what you heard from the beginning abides in you, you also will abide in the Son and in the Father. And this is the promise that he has promised us—eternal life.

(1 John 2:24-25)

God has promised us eternal life. Take a moment with that. We are created to be eternal beings. As a gift, because of Jesus Christ, our souls will live forever. We are given this gift of eternal life through the death and resurrection of our Savior Jesus Christ. We are also given free will to choose the gift of eternal life the Bible talks about.

God gave us the ability to make decisions on our own, and it is up to us whether or not to serve him. I pray that you have come to a point in your life where you realize that you can't make it without the One who created you. If you have not made the choice to accept Jesus as Savior, it might seem like you have everything under control, but inside you may feel empty and deeply unsatisfied. I pray for those of you who have surrendered to Christ, and acknowledged that you need him to forgive you

and make you new, that you fully grasp all the richness contained in eternal life.

We are eternal beings and we will live on after our physical bodies die. When Jesus Christ died on the cross, he took our place. Every sin ever committed was all put on him, the One who never sinned. He also took the results of what those sins would produce to the cross. Jesus took on the guilt, shame, pain, anger, bitterness, sorrow, agony, heartache, misery, anguish, and deep suffering so we wouldn't have to. He did this for us so we can go to heaven and have the wonderful benefits that the Word of God promises us. My friends, please understand that. Take a moment with *all* that this awesome promise of eternal life represents. Christ took it all, so *give it to him*!

There are consequences as a result of sin. Believe me, I know the pain of realizing just how bad life has treated you, and all the effects those wrong choices have on the physical body and mental state. I know because I have been at the bottom struggling just to look up. I also know that the more I get to know the One who has set me free, the more I am able to partake in what is already there. Christ chose to die on the cross so that he could spend eternity with us. The Bible says that he was unrecognizable because of being beaten and punished so horribly. Isaiah 53:5 says, "But he was wounded for our transgressions, he was bruised for our iniquities: The chastisement for our peace was upon him and by his stripes we are healed." He went through this for us all, so that we can have eternal peace with God. This is a promise that cannot be broken or changed.

Please accept all that he has done through his life, death and resurrection. Begin to live your life in victory—not stuck to your own cross of punishment, paying for something you don't owe anything for. Nothing can change what has happened, but God can completely change you. Begin to live your life with him, the One who rose from the dead and is seated at the right hand of the Father in heaven. He is waiting for you to accept him because

he has chosen you. He loves you and is longing for an eternal relationship with you. And that, my friend, is a promise!

And this is the testimony: that God has given us eternal life, and this life is in his Son. He who has the Son has life; he who does not have the Son of God does not have life. These things I have written to you who believe in the name of the Son of God, that you may know that you have eternal life, and that you may continue to believe in the name of the Son of God.

(1 John 5:11-13)

SOMETHING TO THINK ABOUT...

No matter what has happened in your life or what you are going through right now, if you have accepted Jesus Christ as your personal Savior you will be in heaven someday. Think about how having eternal life can change your life. Think about how you should be living your life knowing that you have God on your side.

Today, I want you to spend the day thanking God for all the promises he has given you. Start by writing him a worship song of praise. It doesn't have to sound like the songs your church worship team sings; just let it sound like it came from your heart. Just release your praises to flow from the inside of you. The book of Psalms says it is good to sing praises to our God, and that praise is pleasant and beautiful. So, my sweet sister, sing praises to your God and let him know your heart!

GIVING IT UP!

~∰©

And I thank Christ Jesus our Lord who has enabled me, because he counted me faithful, putting me into the ministry, although I was formerly a blasphemer, a persecutor, and an insolent man; but, I obtained mercy because I did it ignorantly in unbelief. And the grace of our Lord was exceedingly abundant, with faith and love, which are in Christ Jesus. This is a faithful saying and worthy of all acceptance, that Christ Jesus came into the world to save sinners, of whom I am chief.

(1 Tim. 1:12-15)

What a road we travel on from the instant we accept Christ to the time when God really begins the maturation process in our lives. I know that the Holy Spirit is working in our lives from day one, but when we fully acknowledge who we are without Christ—and understand what we want to be with Christ—that, I think, is when the cocoons of our hearts begin to crack and we really begin our life.

I have experienced the "honeymoon stage" with God when I first surrendered to his call to be born again. Oh, how well I remember it. Every time I read my Bible, it was like opening

up those gold coins with the chocolate inside. I couldn't believe that the words meant so much, and made so much sense. It was a wonderful feeling. I knew my life had taken a turn for the better.

As time went on, I knew God was calling me to go deeper. At first, I didn't quite know what all this "flesh" talk was about. In fact, I was rather fond of my "flesh" and thought nothing was wrong with it. God loves me, his Word is the truth, and I am going to heaven. That sums it up. So I thought.

His Word is so full and so rich. The more the Word gets into you, the fuller and richer your life will be. However, here is God's formula to have abundant life: the more of him you put in, the more of you that needs to come out. Believe me, this is not such an easy task. We like to be self-centered and comfy in our own little world. We like going to church or Bible study week after week, but we are not really interested in applying what we learned, nor do we feel like reaching out to others. Face it—we humans like to be selfish! But God wants so much more for us. He wants us to be more like Jesus day by day, and when we look at the life of Christ in the gospels, we see that his life on earth was so full spiritually, even though he didn't physically have a lot. He truly had an abundant life.

Look at the life of Paul, writer of 1 Timothy. He was totally against Christianity before he was saved. His transformation is extraordinary. Paul's testimony is truly inspiring and incredibly motivating. His salvation was dramatic and sudden, and Paul almost immediately began to seek the abundant things of God. He knew that he must put off his former self to have his life become spiritually full and complete. He began to make the life of Christ his guide. He began to see his true nature. He began to make it a point to empty himself so that he could be full of Christ. Paul stressed that our behavior should reflect that of Jesus, whom we accepted to dwell in our new heart.

The Holy Spirit is willing and able to change you from the inside out, and to set you free from every wrong in your life. Do you want to be free—free to love and serve him in abundance? We can have abundant life here on earth because he has changed us from the inside out. The abundant life is the key to freedom. Jesus paid the ultimate price when his life was sacrificed on the cross for the forgiveness of sins, and his free gift of salvation enables us to even think of our lives as abundant in him.

But what does that mean if we want an abundant life? We must start by taking internal inventory and praying that God reveals to us exactly what is keeping us from the abundant life in him. Ask him to dwell deeper as you begin to let go of your former self. Remember: God loves you and he wants the best for you, so give it up!

> Meditate on these things; give yourself entirely to them, that your progress may be evident to all. Take heed to yourself and to the doctrine. Continue in them, for in doing this you will save both yourself and those who hear you.
> (1 Tim. 4:15-16)

SOMETHING TO THINK ABOUT...

What do you have to give up to receive abundant life in Christ? What is holding you back from going deeper with God? Write a prayer to God asking for his help so that you can grow deeper in your walk with him and experience abundant life in him.

VICTORIOUS

Then Jesus said to those Jews who believed him, "If you abide
in my word, you are my disciples indeed. And you shall know
the truth, and the truth shall make you free."

(John 8:31-32)

A few years after I was saved, I went through a period of great
pain and suffering. I felt as though God had left me alone to
bear enormous sorrow and overwhelming grief. Looking back,
I know it was the time in my life when God was teaching me
to receive the treasures that his Word talks about. I had to be
"skinned" with nothing left but my innermost being revealed.
I had to fully expose what was on the inside of me. I had to
face what I had crammed down in the depths of my soul for
so long. I had to bleed, hurt, and mourn, all at the same time.
That is when I had to leave my flesh behind and begin to cling
to nothing but the hem of my Savior's garment.

I had to feel death so I could live. Oh, how I wanted to live
during that time. I wanted to taste the freedom the Bible talks
about. But, in order to be free, one must know what it is like
to be bound. To succeed, one must know what it means to fail.

To have victory, one must have been defeated. I was defeated, but it was in my deep anguish that I was able to begin to apply God's truth.

From the time we are born, we are shaped and influenced by what we see, hear, feel, and experience. That is what makes up "our truth." We are the product of our environment, and whatever we are surrounded with, we absorb and accept as our reality. Our perception becomes fact, and what influences us becomes the result.

Thank the Lord, our Savior comes in to give us his truth so that we can have true victory and be set free from "our truth." God is nothing but pure truth, and his Word is a testimony to who he is and how he feels about his creation. We are his handiwork. We bear his image. We have access to him and all his riches and glory, and that is the truth. We must stand firm and believe that, because it is the absolute key to Christian victory.

Life is difficult and full of pain. I lived part of my life without a personal relationship with Christ, and I had to face my painful and traumatic past, including the choices I made without him. That is when I felt like I was being devoured. I didn't think I would make it through those times of realizing what I had done. But that is when I learned to fight for my life in Christ by replacing "my truths" with his truths. That is why I can boldly say, "And I know the truth, and it has made me free!"

> There is therefore now no condemnation to those who are in Christ Jesus, who do not walk according to the flesh, but according to the Spirit. For the law of the Spirit of life in Christ Jesus has made me free from the law of sin and death.
>
> (Rom. 8:1-2)

Something to think about...

As the final seconds count down in the championship game, the score is tied and the ball is thrown to you. The time begins to run out, and the crowd is on its feet. Just before the buzzer sounds, you make a heroic attempt to heave the ball with all your might across the gymnasium. With your eyes closed tight and a silent prayer flashing through your mind, you hear the most wonderful sound in the whole world. *Swoosh!* You did it! The game-winning basket, and your team takes home the title! Can you imagine how you would feel at that moment? Your team mates would hoist you up on their shoulders, and they would ecstatically chant your name.

If you have Jesus as your Lord, then that is what your life in him is like. Pure victory, and then some! However, we all still have issues that we struggle with. Sometimes you will feel like you are back on the losing team. But you don't have to stay there, because God is always looking for you—an MVP—to join him on his team.

List the areas in your life where you have had difficulty finding victory. As you continue on your journey through this book, keep referring back to this exercise and keep praying that God will give you the strength and the victory in these areas.

LET GO!

In him we have redemption through his blood, the forgiveness
of sins, according to the riches of his grace. For by grace you
have been saved through faith, and that not of yourselves; it
is the gift of God.

(Eph. 1:7; 2:8)

The grace of God isn't something I take lightly anymore. When I
was going through my time of total anguish and deep depression,
I felt as though God had left me completely. It was the time in
my life when God allowed everything from my past to surface
so that he could heal, deliver and set me free from all that had
held me captive.

During that season of my life, every time I closed my eyes, I
saw myself holding on to the bars of a dark and cold prison. It was
a haunting image, and with the help of Satan, I had convinced
myself that I belonged there. I truly believed that I deserved to
be held captive in this mental cell. I had placed myself there as
a reminder of my sin, so that somehow I could pay for all I had
done. I wanted to show God how sorry I was and that I was
willing to sacrifice in my own self-punishment.

Then one day, in his mighty power and his infinite grace, God gave me a vision like none other. He told me to close my eyes and picture that prison. There it was, my cold and damp little cell. There I was, desperately gripping the cell bars so tightly that my knuckles were white. In this vision I saw myself looking down in total defeat. Then God spoke. "Turn around," he said. I was so afraid that he was going to show me my sins. I remember feeling the urge to tell myself to just keep looking down. God spoke again, but this time it was gentler than before. "Turn around," he said. What I saw blew me away.

I slowly and trustfully lifted my head and opened my eyes. To my amazement I saw that I was holding onto the outside of the prison window. I then turned my head, and there behind me was the most beautiful, vast mountain scene with the most glorious wildflowers blowing in a warm, sweet breeze. I was overwhelmed, overjoyed and shocked, all at the same time. I could not believe what I was seeing.

Then he whispered in my ear, "You have been on the outside this whole time! Now let go, and I will be with you!" With that, I turned around to have one last look at where I had been before. What I then saw brought tears to my eyes and fullness to my heart. There, sitting inside that tiny cell was Jesus Christ looking at me and gently nodding his head as if to say, 'It's alright to let go. I have it all taken care of.'

It was at that moment in my life when I knew exactly what grace meant. It was at that moment in my vision when I realized that I had heard the voice of God clearly, had seen the wind of the Holy Spirit plainly, and had witnessed the love of Jesus Christ personally. It was then that I knew I had to finally let go.

...To open their eyes, in order to turn them from darkness to light, and from the power of Satan to God, that they may receive forgiveness of sins and an inheritance among those who are sanctified by faith in Me.

(Acts 26:18)

SOMETHING TO THINK ABOUT...

What has been holding you back? Have you placed yourself in a prison? Are you trying to pay for something that has been freely given? Have you been holding onto something that isn't even there anymore? Are you afraid to let go of your past and let God take care of it?

After reading this, close your eyes and picture yourself in the presence of God. What do you see? Do you see yourself in a positive way with the favor of God upon you? Or do you see yourself as an outcast, bound to the chains of a mental cell, like I did? Remember: God is with you, and Jesus Christ has it all taken care of. It is time to turn around and let go!

Journey through your thoughts with words.

SHAKE IT OFF

For if we have been united together in the likeness of his death, certainly we also shall be in the likeness of his resurrection, knowing this, that our old man was crucified with him, that the body of sin might be done away with, that we should no longer be slaves of sin.

(Rom. 6:5-6)

Think back to a time in your life when you were not serving God, and worshiping the Lord Jesus Christ was not even a thought in your mind. If you can't because you have been a faithful follower since early in life, then praise God. If you can't because you have not yet given your heart to God or just recently did, then praise God—you have a lot to look forward to.

Life is an amazingly difficult voyage. I do not think God intended it to be completely calm and entirely smooth, or else the Bible wouldn't have included examples, stories, and lessons that consist of people facing difficult times and rough journeys. I am so thankful that my life, as complicated and trying as it was, has not been as terribly tragic and unbearable as some of the accounts I have heard about. I pray for those who have been

through extraordinary situations. I hope that they know about the mercy and love of God and his comfort.

I am so grateful for the night that I cried out to God to save me. I cannot imagine what my life would be like if I had not. My husband and I sometimes sit and reflect on our former selves. How incredibly different I am. I am totally unrecognizable to my former self, as I should be. I am a brand new creature, totally renewed in Christ Jesus. I am righteous and acceptable to God. I am the dwelling place of the Holy Spirit, set apart for good works. I am God's daughter and I am free from the bondage of sin. I do not have to think the same thoughts, do the same things, or act the same way. I have the power of the Resurrected One.

My life before Christ seems so far away and so detached from who I am now. I am who God created me to be from the foundations of the earth. I am now living the life he died to give me. I am no longer living for myself, seeking the things that satisfy my own selfish ways. I am no longer a slave to those things that led me into a sinful and disobedient lifestyle. The part of me that desired to live according to my feelings died, and the part of me that desires to worship and fellowship with God was resurrected. I am totally changed from the inside out.

I am so thankful that I responded to his call, and that I shook off my former self. I am so thankful that my "is" is better than my "was." I am so thankful that I, as one who was a slave to sin and am now a slave to righteousness, can share my life with you. I pray that you too have shaken off your former self and have learned who you are in him as well.

> That you put off, concerning your former conduct, the old man which grows corrupt according to the deceitful lusts, and be renewed in the spirit of your mind, and that you put on the new man which was created according to God, in true righteousness and holiness.
>
> (Eph. 4:22-24)

SOMETHING TO THINK ABOUT...

When is your spiritual birthday? Do you have one? If you can remember the exact date, or if you can just remember which decade, make it a point to celebrate the fact that you have been "born again." Celebrate today like it is your spiritual birthday and remember that your "is" is so much better than your "was."

Write yourself a beautiful birthday card.

BECAUSE I SAID SO

⎯~

I say then: Walk in the Spirit, and you shall not fulfill the lust of the flesh. For the flesh lusts against the Spirit, and the Spirit against the flesh; and these are contrary to one another, so that you do not do the things you wish.

(Gal. 5:16-17)

Have you ever felt like crying out to God saying, "I just can't take it anymore? I feel like I am dying inside!" I will never forget the day I cried those exact words to my heavenly Father. God's loving answer to my whimper was simply, "Good." It was in God's response to my heart that I finally began to figure it all out.

It was then that the light went on. I am supposed to feel like I am dying inside; that is the point of "less of me and more of Him," and that is the fundamental nature of Christianity. We are to empty ourselves of what we are, what we want, and what we think, and replace it with what he is, what he wants, and what he thinks. We are not meant to become mindless simpletons, but glorious creatures ready to be used by God to show his unending mercy and magnificent grace. We are to set

aside ourselves and strive to be like Christ. It is only then that we will be truly fulfilled.

In the midst of becoming more like him, we must continue to lay to rest what we selfishly want, and be willing to be humbled by our circumstances. God is wonderful, and no matter how you feel or act, he still loves you and will continue to mold you into what he wants you to be. God has an agenda. He is all-powerful, and his way will always win, no matter what.

It is easy to see the negative aspects of life and get bogged down and discouraged with your flesh. But remember—when you began your journey with your heavenly Father, you received his Spirit. Your flesh fights against this, because it wants to be number one. Here is the good news: we were originally created to have constant fellowship with God. Our Father in his wonderfully sweet way gave us the ability to have a free will, so that we could make choices and have a magnificently complex mind. Unfortunately, sin came into the picture, and our ability to be with him was altered. Thank God that Jesus has provided a way to restore our original relationship with the Father through the ministry of the Holy Spirit. Now we are capable of having the Spirit of the living God on the inside, so that what God wants will eventually become what we want.

Nevertheless, we have to deal with our own human nature. More often than not, it contradicts the ways of God. So just hang in there, sweet sister. Remember, God is God and it is about him, not us. After all, our heavenly Father actually does know best!

> Trust in the Lord, and do good; Dwell in the land, and feed on His faithfulness. Delight yourself in the Lord and he will give you the desires of your heart.
>
> (Ps. 37:3-4)

SOMETHING TO THINK ABOUT...

We are in a battle—a spiritual battle. We want what we want, when we want it. Thank God that his strength and grace is the ultimate in power. In God's Word there is a lot for us to learn, but God is always there to help.

What concept in the Word of God do you struggle with? What have you read, studied, and thought, "Wow, I cannot do that. It sounds too difficult for me." Write down specific things that you find hard to follow and obey completely. Allow God to help you follow what he requires of you. Pray for his strength and be easy on yourself. Remember, no one has arrived. We all have a human nature, and we all struggle.

DAVID OUR BROTHER

Where can I go from your Spirit? Or where can I flee from
your presence?

(Ps. 139:7)

God is omnipresent. There are no limits to where he can
dwell. There is no place that he can't be. He is in the presence
of everything because he contains everything. There are no
restrictions when it comes to God, and there is nothing that
God cannot do.

David already knew the answer when he cried out to God the
words of Psalm 139. He knew there wasn't anywhere he could
go to escape the mighty hand of God. David, in his wonderfully
human way, had come to a point in his life when he began to
grasp that he could not run or hide from God. He had learned
that God's grace could handle his sin.

In this psalm, David was welcoming God's presence in his
innermost being. He understood that through God's complete
access in his life he would receive deliverance and peace. David
knew that his sin was great, but that God's mercy was greater.
We can learn a lot from our fellow believer.

I remember learning more about David when I began walking with the Lord. Previously, I just thought all the Bible stories were about perfect people who God loved because they were good. I obviously hadn't met my brother, David. God hates sin, but he loves his children. When we have continuous sin in our lives, or unconfessed sin that hasn't been properly dealt with, I believe it is God's desire to reveal our sin to us. Sometimes it is easy for us to recognize and work on it, and sometimes it is more difficult because it has been deep-rooted, ignored, and denied. On my continuing journey on the road to Christ-likeness, I have learned more from those Christians who are honest with themselves and others as to who and what they would be without Christ. I have gotten so much hope, inspiration and encouragement from those who have recognized, confessed, learned, and moved on from their sins.

David is a wonderful example of this openness. David, a man after God's own heart, led an extraordinary life. Yet he still had to deal with all the sin issues that face humanity. Taking responsibility was difficult and painful, but through his shortcomings and mistakes, David's knowledge of the Lord grew extensively, and he understood the gifts from our heavenly Father. He wrote about the riches of grace and mercy, and he praised God for his majesty and sovereignty. David, in all his frailty, knew the heart of God and yearned for it. What an awesome example of a brother who wasn't afraid to be honest, because he knew the character of an all-knowing God.

You are my hiding place: You shall preserve me from trouble: You shall surround me with songs of deliverance.

(Ps. 32:7)

SOMETHING TO THINK ABOUT...

As you expand your knowledge of David our brother, or perhaps reflect on your extensive study of this remarkable saint, remember—there is nowhere you can go without God and his unending mercy and grace. Would you want to?

Begin reading through the book of Psalms in your Bible. Read a few chapters a day. See if you recognize any of your own struggles, and take note of how God brought David through some of the difficult times. You will be greatly blessed!

As you read and learn about David, write down some similarities and differences between yourself and David.

THE VINE

I am the true vine, and my Father is the vinedresser. Every branch in me that does not bear fruit he takes away; and every branch that bears fruit he prunes, that it may bear more fruit.

(John 15:1-2)

Who is God? Is he the One who created the heavens and the Earth? Is he the One who made man in his image from the dust of the land? Is he the One who breathed life into us? Is he the One who knew us from the beginning? Is he the One who sent Jesus so that we can fellowship with him? Is he the One you talked to last night before you closed your eyes? Is he the One you spoke to this morning and thanked as you woke up and made it to another day? Is he the One you pray to and trust for your everyday issues? Is he the One you rely upon for absolutely everything in your life? Is he the One you have entrusted with your life, as well as your family's?

Is he the One to whom you have given your problems? Is he the One to whom you have given your pain, sorrows, heartaches, guilt, and shame? Is he the One who knows your fears, dreams

and hopes? Is he the One you cried out to when you were faced with your eternal destiny? Is he the One you called upon to save you from your sins? Is he the One who looks at you and sees the blood of Jesus and is satisfied? Is he the One who has filled you with his Spirit so that you can live a life full of righteousness, peace, and joy? Is he the One who began a good work in you, so that you will be a trophy of his grace and a display of his splendor?

Is he the One you approach first to consult about a major life decision? Is he the One you trust fully with your heart, knowing he will never break it? Is he the One you tell others about on a consistent basis? Is he the One your husband and children see when they look at you? Is he the One you dress up for on Sunday mornings? Is he the One you lift your hands and voice to when you sing? Is he the One you worship with your words at all times when you speak? Is he the One you confess your weaknesses to in hopes of gaining his strength?

Is he the One you take to work, school, shopping, or to your in-laws? Is he the One you lean on when times are tough? Is he the One you want to be like through Christ? Is he the One you obey, even when it is hard? Is he the One you are searching for? Is he the One who knows you and still loves you? Is he the One who will be pleased to see your fruit and will prune you so that you will bear more? Is he the One who will see your fruit and *not* be pleased? Is he the One who will deny you as you have denied him? Is he the One who will say, "Depart from me, I never knew you."? Is he the One who is calling you right now to accept him as Savior? Is he the One you will answer? Is he the One?...

Seek the Lord while he may be found, call upon him while he is near.

(Isa. 55:6)

SOMETHING TO THINK ABOUT...

Is he the One? If he is, write about some of the people who have showed you throughout your life that he is the One. If he is not the One, explain why.

LOOK UP!

I will extol you, O Lord, for you have lifted me up, and not let my foes rejoice over me. O Lord my God, I cried out to you, and you healed me. O Lord, you brought my soul up from the grave; you have kept me alive, that I should not go down to the pit. Sing praise to the Lord, you saints of his, and give thanks at the remembrance of his holy name.

(Ps. 30:1-4)

Praising is one of the best ways to bring you out of despair, depression and defeat. It can be the wings that lift the heaviness off your heart. It can jump-start your spirits so that you can focus on God instead of your circumstances. It can be the cry of your soul that longs for the presence of the Almighty.

Praise can be what it was intended when you push aside all reservations and apprehensions. Praise in its purest form is an expression of admiration and gratitude for blessings received. In its simplest form, praise is acknowledging God for who he is in all his wondrous glory. Praise can be exemplified in many ways: praying silently or singing songs and hymns out loud. Praise can be shown through dancing and movement or writing and com-

munication. Mostly, praise can be expressed just through living a life of gratitude and thanksgiving to our heavenly Father.

Praise is a deliberate act, a choice of action, and an attitude of heart. Praise is a privilege and an honor. It is a blessing and a benefit. Would God be who he is without our praise? Of course. Would we be who we are today without praising God for the great and mighty things he has done in our lives? Absolutely not!

Who benefits from praising God? We do! Who has been there for you when no one else cared? Who lifted you up and sheltered you from harm? Who was there when you were hurting, crying and bleeding? Who healed you, delivered you, and sanctified you? Who saved your soul from the punishment of death? Who sent Jesus to the cross so that we can be citizens of heaven? Who protects you, keeps you, and holds you in the palm of his hand? Who created you with a holy purpose and sealed you with a holy promise? Who gave you all the good things in your life? Who is worthy of the highest praise and adoration? God!

Praise him in the morning. Praise him in the evening. Praise him in the difficult times. Make it a point to praise him even when you don't feel like it, because that is when you need it most.

God is God. He is all knowing, all ruling and all-powerful. He will be the same today and tomorrow regardless of our praises. We, however, will *not* change for the better without praises on our lips. Praising our Lord is one of the most important aspects of our Christian walk. Praise takes the Word of God, puts it in our hearts, and stirs it around so that the Word saturates our innermost being. Praise takes the focus off our weakness and puts God's strength in the spotlight. Praise diminishes us and exalts him. Praise keeps it all in perspective. Praise God!

Make a joyful shout to the Lord, all you lands! Serve the Lord
with gladness: Come before his presence with singing. Know
that the Lord, he is God; It is he who has made us, and not
we ourselves; we are his people and the sheep of his pasture.
Enter into his gates with thanksgiving, and into his courts
with praise. Be thankful to him and bless his name. For the
Lord is good; his mercy is everlasting, and his truth endures
to all generations.

(Ps. 100)

SOMETHING TO THINK ABOUT...

Put on some praise music. If you don't have any, then find some! (You can locate good Christian praise music at any Christian bookstore, online, or perhaps at your church. You can even find different styles to fit your taste; just make sure the artists are Christians!) Listen to the words and praise your Father in heaven. Sing and dance if you feel comfortable! Just praise him in song today!

Write about a time of praise when something wonderful happened as a direct result of your praising.

Serving Him

And now, Israel, what does the Lord your God require of you, but to fear the Lord your God, to walk in all his ways and to love him, to serve the Lord your God with all your heart and with all your soul, and to keep the commandments of the Lord and his statues which I command you today for your good?

(Deut. 10: 12-13)

What does the Lord require of me? Do you ask yourself that question? I know I do. I think it is such a luxury, as a Christian, to be able to go to the Word of God to get the answers for all of life's burning questions: What is my purpose? What is God's will for my life? What does the Lord require of me?

Deuteronomy has the response to the question of God's requirements. First and foremost God wants us to fear him. We are not to be afraid of who we are with him, but rather fear who we are without him. We are to reverence the Almighty and sincerely worship him. We are to desire his favor and dread his wrath. We must possess the fear of the Lord, understand it as a

blessing, and appreciate it as protection so we can conscientiously walk in his ways and obey his commandments.

God is a gentle and loving Father, yet he is very serious when it comes to fearing him. This is because he knows our tendency to be disobedient. Without question, we must strive to always be walking in his ways. We must live our lives before God, even when no one is watching! If you secretly speak about your fellow brother or sister in Christ, God can hear you. If you don't tithe this week because you had to shop the "biggest sale of the season," God can see you. God knows us, inside and out. He knows what is within our heart.

Live before God. Make it you and him. Love him by your thoughts and deeds. Serve him by serving others. Live out his love by displaying the fruit of the Spirit: love, joy, peace, longsuffering, kindness, goodness, faithfulness, gentleness and self-control. Keep his commandments by trusting in him, leaning on the Holy Spirit, reading his Word, and praying consistently. That is what the Lord requires of all his children.

If you want to experience God and all the spiritual blessings that the Bible says we have, then make it your life's goal to live before him in fear. Walk in his ways and serve him with all your might, keeping his commandments.

> The Lord will establish you as a holy people to himself, just as he has sworn to you, if you keep the commandments of the Lord your God and walk in his ways.
>
> (Deut. 28:9)

SOMETHING TO THINK ABOUT...

If your walk with the Lord were like serving in a restaurant, what kind of tip would God leave for you? Think about it. What kind of service are you giving God? Do you leave him there waiting for you to take his order? Do you forget to give him refills on his water? Do you serve him bad food on a dirty plate? Do you drop his silverware on the floor and give it to him anyway? Do you spit on his food? How would you rate your service to the Lord? Think about it...

Describe your service to the Lord. Think of ways you could improve.

HIS SPIRIT

No one has seen God at any time. If we love one another, God abides in us, and his love has been perfected in us. By this we know that we abide in him, and he in us, because he has given us of his Spirit."

(1 John 4:12-13)

If you have surrendered your life completely to the living God, accepted all that he has done for you, and believe that the Word of God is true, then you have the Spirit of God in your heart. You have the same Spirit that came to Mary telling her that she would give birth to the Savior of the world. You have the same Spirit that came upon Jesus at his baptism in the beginning of his ministry. You have the same Spirit that was with the disciples when great and mighty miracles were performed in his name. You have the same Spirit that was with Jesus as he quietly endured the cross. You have the same Spirit that raised Jesus from the dead, so that our sinful nature would be forgiven. You have the same Spirit that filled the believers at Pentecost so that they could go out with the power of Jesus to spread the Good News. And

most importantly, you have the same Spirit in you that saved your soul from an eternal destiny in a lake of fire.

We have been given the most precious gift ever given—the Holy Spirit. We have been given a new life, a second chance, a fresh start, a clean slate, a new beginning, a purpose-filled destiny, a great hope, an unsoiled past, a bright future, a spotless record, a changed heart, and an eternal place in heaven with God the Father. We have the ability to live our lives the way the Bible promises, with righteousness, peace, and joy. Because of the great sacrifice Jesus so lovingly made, we have his Spirit dwelling in our hearts. We have all that Jesus offers to the world by his Spirit, and we have all the "fruit" (traits) that the Spirit possesses so that we can be a witness for the kingdom.

As we know, Galatians 5:22-23 says, "But the fruit of the Spirit is love, joy, peace, longsuffering, kindness, goodness, faithfulness, gentleness, (and) self-control." Does any of this reflect who you are? Do you love those who speak against you? Do you show joy when you go through trials? Is there a peace about you when you are faced with a challenge? Do you suffer long with those who get on your nerves? Are you kind to your spouse, your parents, or your boss? Do you do good to those who do not care for you? Are you faithful to God by praising and worshipping him everyday? Are you gentle in your tone of voice with your children, your grandchildren, or your neighbor's children? Do you exercise self-control at the dinner table, the buffet line, or the grocery store? Are you truly walking in the Spirit? Faithful one, there is hope for you and me.

The Spirit of God is gentle and patient toward us. He is comforting, kind, and knows our shortcomings and weaknesses. He desperately wants to change us and conform us to the image of God. He is our companion: the one who comes up beside us to take our hand and guide us into his ways. He is our comforter: the one who is with us in times of great pain and suffering. He is our counselor: the one who will give us advice in all we do.

And he is our helper: the One who is there for us as our guide to assist in any way possible. He is the Holy Spirit, he is Lord, and He is with you always.

> Now the Lord is the Spirit; and where the Spirit of the Lord is, there is liberty. But we all, with unveiled face beholding as in a mirror the glory of the Lord, are being transformed into the same image from glory to glory, just as by the Spirit of the Lord.
>
> (2 Cor. 3:17-18)

SOMETHING TO THINK ABOUT...

What role does the Holy Spirit play in your life? Do you sense his presence? Do you welcome his presence? Write down ways that you can become more sensitive to the Holy Spirit of God.

SELF-CONTROL

I would have lost heart, unless I had believed that I would see the goodness of the Lord in the land of the living. Wait on the Lord; be of good courage, and he shall strengthen your heart; Wait, I say, on the Lord!

(Ps. 27:13-14)

I've read that the average person spends most of his or her lifetime waiting. On an average day we spend our time waiting in line, in traffic, for dinner, an appointment, the bus, the laundry, and on the phone. It is incredible the things we have to wait for. The list could be as long as there are people in this world. We spend more of our time waiting than we do almost anything else. Waiting is inevitable and unavoidable.

If you are like me, the thought of waiting for something doesn't sound too exciting. In fact, it sounds downright tiresome. However, when David wrote this psalm he was speaking of a different kind of waiting. He was speaking of a waiting that not only results in seeing the glory of God, but a waiting that results in developing self-control.

In all believers there are two distinct parts to our being: the spiritual and the carnal. Both of these parts are equipped and designed with the strength and willpower to wait. The carnal (human flesh) nature will wait on something to get to the desired results that will temporarily satisfy the flesh. This type of waiting, though it can produce some positive characteristics in you, usually results in temporary satisfaction. The spiritual (renewed) nature in a Christian longs for and desires the things of God that are eternal and full of life. Our spiritual side is designed to wait as well, so that it can become closer to God and develop a stronger relationship with him. It yearns for that and was created to do so.

We know that God is nothing less than excellent and superb, and that his blessings are limitless and vast. We also know that God requires his children to walk worthy and upright. He desires for us to be constantly striving onward and upward for his sake and his glory. He wants us to be sensitive to his promptings to do his will, and to be sensitive to his call to serve him without question, even if it requires us to develop self-control and to wait.

The Bible says that living a life sold out to God is not easy or without struggle. It says that when we cast our care upon him and let him bear our loads, we will find rest for our souls. It does not say that he will immediately solve every problem. He requires us to have the self-control to be patient.

First we must go to him and give him control of our life. Then he will take care of our burdens. It is in the act of going to him that he will honor and bless. Only we can decide who will be in control—the Spirit or the flesh. That is why it is important that we live in the Spirit.

The ministry of the Holy Spirit is to help guide us and fill us with the character of Christ through the fruit of the Spirit. The fruit of the Spirit, as defined and explained in Galatians 5:22-23, is the very personality of Jesus himself. All qualities of the fruit

of the Spirit are extremely important and need to be developed in our lives. But as our walk with God strengthens and our need to wait on eternal things continues, we must focus on the fruit of self-control. Self-control is vital, because it is the springboard that will allow the other fruit traits to show in your life.

You must control the tongue to show kindness. You must control your anger to show love. You must control your emotions to show peace. And you must control yourself to show patience, especially when you wait on God!

For a good tree does not bear bad fruit, nor does a bad tree bear good fruit.

(Luke 6:43)

SOMETHING TO THINK ABOUT...

Read Galatians 5:16-26. When you are finished, read it again! Think of ways you can show self-control, especially as you wait on God. Write down your thoughts.

LIGHT

Do all things without complaining and disputing, that you may become blameless and harmless, children of God without fault in the midst of a crooked and perverse generation, among whom you shine as lights in the world, holding fast the word of life, so that I may rejoice in the day of Christ that I have not run in vain or labored in vain.

(Phil. 2:14-16)

Paul, who wrote the epistle to the Philippians, is an amazing example of what God can do in a willing believer. In Philippians, Paul shows us how we can be practical Christians in the real world. Even though it is not always easy to be obedient, patient, joyful, and good, it is required if we want to show who Jesus is.

Paul's testimony is amazing. He hated Christians and even approved of putting them to death. Then came his salvation, and Paul became an awesome witness and preacher of the gospel. The Bible shows us that if Paul can be forgiven and live a challenging life, full of joy, then there is no excuse for us. If we follow Paul's example by involving joy and rejoicing in our lives, and make

our minds up to do so, then our light will shine even more in this dark and hopeless world.

God knows it is hard to keep our thoughts focused on rejoicing, especially in the midst of turmoil and hardships. It is in those times, however, that we have the opportunity to let the Lord in us shine through. That is when our Father cultivates us and shows us his grace and his strength. He gives us exactly what is needed on the inside so his light can shine on the outside. We have to be willing and confident of who we are in him, and then put aside what we are without him. He desires our behavior to reflect the Word of God so that we can shine for him more and more.

Our minds are an amazing place. Thoughts come and go so easily. That is why the Bible tells us to guard our minds, dwell on things that are pleasing to the Lord, and focus on rejoicing. It is vital to line up our thinking with the Word of God. We need to purposely think about being joyful. We need to retrain our minds to automatically go to rejoicing and satisfaction with God instead of going to fear and dread. We need to change our focus and direction and look to God in all things. And we need to do all this regardless of what is going on in our lives.

I am so thankful that God has always been faithful, even when I have not. I have learned to have joy at the core of my life. I have learned to replace my complaints with praise. It has been through the refinement of my mind and my faith in God that I have been able to come this far. It takes enormous effort to retrain your thoughts, and it takes all the grace that God gives, but the results are awesome and will last forever. After all, the more joy in your life, the brighter your light will shine!

You will show me the path of life; In your presence is fullness of joy; At your right hand are pleasures forevermore.

(Ps. 16:11)

Strengthened with all might, according to his glorious power, for all patience and longsuffering with joy; giving thanks to the Father who has qualified us to be partakers of the inheritance of the saints in the light.

(Col. 1:11-12)

SOMETHING TO THINK ABOUT...

Take time today to listen to the words that come from your mouth. Pay close attention to your inner thought dialogue. Do they line up with God's Word? Are they a representation of the light of Christ? Take some personal time to pray and ask God to help you retrain your thoughts and words to rejoice in whatever you're doing or whatever you are going through. I know it will be difficult to rejoice when you feel like murmuring and complaining. Read all of Philippians and realize that Paul was imprisoned when he said, "Rejoice, in the Lord always, again I say rejoice!" Pray for me as I pray for you to rejoice, again I say *rejoice!*

Think of your trials and struggles. How are you handling them? What words are you speaking over your situation? What thoughts are influencing your actions? Write down all the things that stress you out and how you are handling them. Then take a good look at your list. Think and pray about how you can improve your situations with the light of God's Word.

HOPE

~⁂◯

Therefore, having been justified by faith, we have peace with God through our Lord Jesus Christ, through whom also we have access by faith into this grace in which we stand, and rejoice in hope of the glory of God. And not only that, but we also glory in tribulations, knowing that tribulation produces perseverance; and perseverance, character; and character, hope. Now hope does not disappoint, because the love of God has been poured out in our hearts by the Holy Spirit who was given to us.

(Rom. 5:1-5)

When God began to put on my heart to write, I felt completely inadequate and unprepared. I felt as though I had not matured enough, or learned what I needed to learn in life. I thought that, perhaps, I had not listened to enough sermons, been to enough Bible studies, or prepared enough Sunday school lessons. I just did not feel ready or qualified.

So, I waited to ripen. Even after a few more years of struggle and strain, I still felt insufficient. Then it finally dawned on me that I will never be completely ready. I will never have what it takes to be the perfect author or speaker. I will never have enough

experiences or great things to say or write about. I will never be totally prepared and geared up to do what God has asked of me… unless I have hope.

Hope is at the very heart of our being. God created us to have hope. I love that word, *hope*. It is so powerful, but we must not forget to ground it in Christ. Christ is our hope. He is the only thing we can base anything on. He is the only foundation that will stand firm forever. We have hope only because of him, the one true hope of the glory of God. It is solely because of Christ coming down from heaven to save God's creation from eternal wrath that we can hold our heads up and have hope.

Hope can comfort a hurting mother; hope can help you realize your dreams; hope can heal a broken heart; hope can get you out of bed; hope can open your eyes to the truth of a good future and a forgiven past; hope can save your soul. It is through these times of tribulations that God's true meaning of hope is discovered.

We may never think that we are ready to do what God has asked us to do, but the more we go through and endure, the more that hope is realized, and the more good it produces. Perseverance… character… hope. We have hope because of the love of God in our hearts through the Holy Spirit dwelling in us. That is the core of where our hope is. Just saying that we have hope gives life new meaning, because with hope, from this point on, your life will never be the same, and neither will mine.

Our Jesus has given us a vision, a dream, and a hope. I pray that you have the hope that things will get better; the hope that tomorrow will be easier than today; the hope that we can survive in this life; and the hope that only comes from knowing the one true hope, Jesus Christ. There are no certainties in this world, but with God, there is always hope.

For the grace of God that brings salvation has appeared to all men, teaching us that, denying ungodliness and worldly lusts, we should live soberly, righteously, and godly in the present age, looking for the hope and glorious appearing of our great God and Savior Jesus Christ, who gave himself for us, that he might redeem us from every lawless deed and purify for himself his own special people, zealous for good works.

(Titus 2:11-14)

SOMETHING TO THINK ABOUT...

Think back to a time in your life when there wasn't a doubt in your mind that you would be what you most desired to be. I remember when I had no hesitation that I would be a ballerina, dancing in the most glorious places with the prettiest costume and the pinkest shoes. I remember literally thinking that being a ballerina would be my job for the rest of my life. I had absolutely no uncertainty in thinking that. It was a dream and a hope. My shoes have now faded and I would feel quite silly in a tutu. And the truth of the matter is, I was not the best in my class, if you know what I mean. But I had hope, and that made it attainable to me.

Thank God, his hope is different. When we have biblical hope we expect, trust, and anticipate with pleasure the truths and the assurances that is promised us in his Word. We know the Scripture is fact, and all that it says about us is a reality. When we have Jesus we don't have to wish for things or crave things; we have the total expectation that the good work Jesus began in us will be completed and perfected.

Take a moment to reflect upon some of the things you had hoped for as a young girl. How did you picture your life? What is different? What is similar? Now take a look at yourself through Jesus' eyes. What is the focus of your hope, now that you are seeking a life closer to God? Do you have a deeper sense of hope? Does your vision of hope now have a greater purpose? If you are still quite unsure of the hope that is in knowing Christ Jesus, then begin by reading Romans chapter 5 in your Bible. Write your thoughts, feelings and hopes.

GLADNESS

Serve the Lord with gladness; Come before his presence with singing. Know that the Lord, he is God; It is he who made us, and not we ourselves; We are his people and the sheep of his pasture.

(Ps. 100:2-3)

I praise God he created us. The God who fashioned all the earth by speaking it into existence formed me and you. Psalm 139:13 says God shaped us in our mother's womb. The scripture reads on, saying God's works are marvelous. We are marvelous! He chose everything about us and he knows exactly what we need when we need it. Our friends and family were handpicked by God to bless and support us, and to shape and mold us.

God created us with a purpose and a holy calling. Jeremiah 29:11 says God's thoughts toward us are to give us a future and a hope. God is good to us, and his ways are perfect. He is wonderful and awesome. He is worthy of our praises. Psalm 100 defines our role to our merciful and gracious God. We are to serve the Lord with gladness in all that we say and do. Even when things get tough and we do not understand why God is

allowing us to suffer, we serve him with gladness. Even when we do not feel like being nice to anyone, including ourselves, we serve him with gladness. Most of all, when we absolutely cannot endure the stresses of life, we serve him with gladness!

It is God who provides, God who sustains, and God who maintains. It is God who protects, God who restores, and God who rewards. It is God who delivers, God who heals, and God who comforts. It is God who is there 24/7, not just 7/11. God is our all in all.

I am so thankful for the mighty presence of God. As we seek for the deeper things of God, may we never cease to serve him with gladness. If we fail to serve him with gladness, we will miss out on what God is doing. If we neglect to serve him with gladness, others will not see the glory of the Lord in us.

Make a new commitment to serve the Lord with gladness; come before him with singing, and know that he is God!

> I will praise you, O Lord, with my whole heart; I will tell of all your marvelous works. I will be glad and rejoice in you; I will sing praise to your name, O Most High.
>
> (Ps. 9:1-2)

SOMETHING TO THINK ABOUT...

Write why you are glad in the Lord. Put a smile on your beautiful face. Let God shine through you today, and others will see you serving the Lord with gladness. Make it a point to share with someone the wonderful things God is doing in your life.

SEEKING

Therefore, as the elect of God, holy and beloved, put on tender mercies, kindness, humility, meekness, longsuffering; bearing with one another, and forgiving one another; even as Christ forgave you, so that you also must do. But above all these things put on love, which is the bond of perfection. And let the peace of God rule in your hearts, to which you were called in one body; and be thankful.

(Col. 3:12-15)

I want to ask you a question. Let's say I was invited to a formal dinner with the president of the United States of America, and I came to you for advice as to what I should wear. In my mind, I wanted to wear my jeans with my red, white, and blue sweater and my favorite cowboy boots. What would you say to me?

Hopefully, as my friend, you would suggest I put on something more appropriate for the occasion. You would probably persuade me to try something more elegant and sophisticated. Perhaps something black with a beautiful string of pearls would be more suitable. If I were still confused, you would probably explain how I am going to be in the presence of a very important and respect-worthy man. His wife will be

there, so the way I present myself is important, especially in front of the couple that is the governing authority over our country. Hopefully, I would get the hint and dress accordingly.

This same basic principle of "dressing for the occasion" can be used when we look deeper into the mighty Word of God. If you are truly seeking the Christ-like life, then let me invite you to a formal dinner with your Lord and Savior.

As born-again, spiritually new, and fully forgiven believers, we have an obligation to the One who created, selected, and called us. If we are genuinely his, then we no longer have the choice to do what we want, when we want, and how we want.

So, as God's guest of honor at his formal dinner party, what have you chosen to wear? Do you wear your mercy hat when you see someone who just spent his or her last dollar on the lottery? Since they are hungry, do you feed them without judgment? Do you put on your kindness shoes to go to the grocery store, and then, when someone steals your parking spot, just look at it as a way to bless them?

Have you put on your best humility bracelet, your shiniest meekness ring, and your most expensive longsuffering earrings so that when someone gets the credit for your work, you can relax and know your work was freely done unto the Lord? When was the last time you wore someone's dirty clothing, so that you could bear their sufferings? How long has it been since you took off the ugly and heavy unforgiveness robe, just as God instructed you to? Is love the most important thing you put on in the morning, or is some perfume with a French name your choice of making a lasting impression? Are you truly seeking a life where the peace of God rules in your thankful heart? Or are you still choosing to eat at a fast food restaurant where the only guidelines are shirts and shoes required? The choice is up to you.

As believers, we are the dwelling place of the Holy Spirit, the elect of God, holy and beloved. We need to seek the things

of God daily. Take off your former self and prepare to dine with the King of Kings, not the burger king. Dress accordingly. Be softhearted, merciful, and kind even if you don't agree with someone's circumstances. Show others the humility and meekness of Christ in you by keeping your opinions and comments to yourself. Choose to be patient when you want to push someone out of the way. Put your arms around your fellow sister who is having a bad day, even if you are having a bad decade. Forgive. Forgive. Then forgive again. Christ says we *must* do this. And just when we think our meal is over and we are too full, the Word of God tells us to put on love, because that is the bond of perfection. Then, the Word of God says, we should let his peace rule in our hearts and be thankful. So, welcome to the table. I hope you came prepared.

> The statues of the Lord are right, rejoicing the heart: The commandment of the Lord is pure, enlightening the eyes; The fear of the Lord is clean, enduring forever; The judgments of the Lord are true and righteous altogether.
>
> (Ps. 19:8-9)

SOMETHING TO THINK ABOUT...

Are you truly seeking a God-led life? Re-read Colossians 3:12-15. Make a personal list of where you have fallen short on each of these requirements. Think about how you treat your family, friends, and even total strangers. Does your life line up to God's standards? Think about it...

SORROW

Now, I rejoice, not that you were made sorry, but that your sorrow led to repentance. For you were made sorry in a godly manner, that you might suffer loss from us in nothing. For godly sorrow produces repentance leading to salvation, not to be regretted; but the sorrow of the world produces death.

(2 Cor. 7:9-10)

Does sin make you sad? When you willfully make a choice to sin, does it bother you? What was it like when you first realized you have sinned against God, and you were partially responsible for nailing Jesus to the cross? When you see unjust things happening to the innocent, do you turn the other way and pretend it is not happening? Think about all the sin in the world. We have a command and a responsibility to help reveal Jesus to those who do not know him. I ask again—does sin make you sad?

In the second letter to the Corinthians, Paul was deeply concerned and disappointed about the immorality in his struggling Corinthian church. In the seventh chapter, he expressed how his hope in writing the truth was not to make the Corinthians sad or sorrowful. He wanted to make them

upset or mournful, so that in their distress over the truth, the reality of their spiritual condition would be revealed and they would repent. That was Paul's great purpose and the calling on his life.

Throughout his ministry, Paul's heartfelt passion was to strengthen and encourage all people of every nation, and the Corinthian people were no exception. He rejoiced in their sorrow, because it produced a change in the direction of their lives. Like Paul, I pray that sin makes you sad, and that it continues to make me sad as well. I pray we as set-apart Christ-seekers never get accustomed to sin. I pray God continues to "clean house" and expose every thing in our lives that are contrary to his ways. I pray every unconfessed, hidden, and unrealized sin is uncovered and dealt with, so that our prayers are not hindered. I pray God uses us to be a witness for his kingdom.

If you have not yet given your life to Christ, and your sin makes you sad, then praise God! Not because you are sad, but because you have come face to face with your spiritual state. God is holy, perfect, and totally without sin or any imperfection. We all are sinners with many flaws, and need the love and forgiveness of Christ to make us complete. Confess you are a sinner, and give your life to God through the sacrifice of Jesus Christ. Begin to see yourself as a new creature in Christ where sin has no authority any longer and its power over you is broken for good. Now go and sin no more!

> Have mercy upon me, O God, according to your loving kindness; according to the multitude of your tender mercies, blot out my transgressions. Wash me thoroughly from my iniquity, and cleanse me from my sin. For I acknowledge my transgressions, and my sin is always before me.
>
> (Ps. 51:1-3)

Something to think about...

Do you still have a past sin that bothers you? Does the enemy keep reminding you of something horrible you have done? Get out a separate piece of paper and write down the sins that keep bothering you. Confess to God that you have sinned against him and ask for his forgiveness. Now take that paper and destroy it.

If you confess your sins, he is faithful to forgive them, once and for all. Write a prayer to God helping you to live a life sensitive to sin.

(If you still struggle with a past that just will not go away, seek counsel from a qualified individual who can help you through your situation. God never intended for you to suffer alone and he has equipped many of his saints to assist you in your time of need.)

FUN AND LAUGHTER

Then our mouth was filled with laughter, and our tongue with singing. Then they said among the nations, "The Lord has done great things for them." The Lord has done great things for us, and we are glad.

(Ps. 126:2-3)

Has the Lord done great things for you? Has he blessed your life above and beyond anything you have asked? Has he answered your prayers in unexpected ways? Are you glad you chose to follow God? Do you see all the amazing and wonderful things God is doing in your life?

When you seek God with a burning passion, sometimes your life will fluctuate between smooth and complex. God's ways are mysterious, but his character is unchanging. Sometimes, we are clueless as to what God's plan for our life is, and other times he gives us a glimpse of what is in store for us if we will trust and obey.

Regardless of where God has placed you, or what he has you involved in, know that beyond a shadow of a doubt it will all work out for his glory. Also, know that working for the Lord

creates challenges in itself. The deliberate act of selflessness can produce character, but if forced can turn into self-sacrifice, which can turn into exhaustion if not properly balanced. I can get so wrapped up in what God has called me to do that I begin to focus on nothing but accomplishing something for the Lord. I can get too serious and forget to have fun for the Lord as well.

That is when my sweet husband comes in to remind me to relax, have fun, and focus on what God has already done in our lives. It is important to show gratitude to God for the people he has lovingly and purposefully placed in your life. I am so thankful for the gift of being able to have fun with godly people.

It blesses me so much when close friends come over to hang out with my family. It helps tremendously when we can relax and laugh together. There is much to be done for the Lord and hard issues in this dark world to deal with. But Jesus came so that we could enjoy our lives. So lean on that, and rest in him as you have some fun and laughter.

A man who has friends must himself be friendly, but there is a friend who sticks closer than a brother.
(Prov. 18:24)

…that their hearts may be encouraged, being knit together in love, and attaining to all riches of the full assurance of understanding, to the knowledge of the mystery of God, both of the Father and of Christ in whom are hidden all the treasures of wisdom and knowledge.
(Col. 2:2-3)

Something to think about...

Make it a point to gather with a group of friends and have fun. Arrange for a special time soon to get together for some fun and laughter. Afterwards, write about your experience.

WEARINESS

And let us not grow weary while doing good, for in due season we shall reap if we do not lose heart.

(Gal. 6:9)

Do you feel physically tired or spiritually weak? Are you completely exhausted? Do you feel faint? Have you wanted to say, "Enough is enough, I need a break!"

As women, I think it is challenging for us to live a life of balance and control. God created us to be wonderfully sensitive and superbly expressive. However, because of our magnified insightfulness, we tend to think and make decisions based on our feelings and our need to express our emotions. This sort of relying upon our feelings and being led by our emotions, if unguarded, can cause us to go overboard and get overwhelmed. This is when we usually begin to go to the extreme of our emotions, grow weary, and lose heart. We then begin to break down and forget our focal point, which leads us to take our eyes and heart off God.

A pastor friend of mine did a wonderful teaching on the heart. He said that the heart is the essence of your life and the

home of your convictions. In the spiritual sense, the heart is the deepest part of you. It is the absolute core of your life. Most important, it is where God does his finest work.

In God's Word, the heart is referred to as your thoughts or feelings. Many things are said in scripture about your heart:

- "Guard your heart."
- "Out of the heart the man speaks."
- "Love with all your heart."
- "God knows and searches the heart."
- "A heart rejoices in the Lord."
- "God will give you a new heart."

It is evident that the heart is absolutely vital in our relationship with the Father. It is apparent that we must give matters of the heart over to Christ so that he can direct our lives. If not, we will definitely faint and grow extremely weary, and we will not be what he has called and directed us to be.

Jesus said, "Blessed are the pure in heart, for they shall see God." Remember, God is all about the heart. It is where he dwells. Ask a child who is being raised in a godly home where Jesus is. They will tell you without hesitation, "Jesus is in my heart." God has given you a new heart, so treat it well. You have the God-given ability to allow him to work in your heart and lead you to live in a balanced and calm manner, with him in control. Allow him to make your heart the essence of your life in Christ and the home of his convictions. Stay focused, do good, and don't lose heart!

> And Hannah prayed and said, "My heart rejoices in the Lord; my horn is exalted in the Lord. I smile at my enemies, because I rejoice in your salvation."
>
> (1 Sam. 2:1)

Something to think about...

Where are you directing your energy? Is it truly going where your heart is leading? Or are you spinning your wheels on things that don't grow and strengthen your heart? Are you doing good just for the sake of trying to "be good"? Or are you doing what moves your heart and shows others the essence of who you are? Does it line up with the Word of God? Or is your energy focused on things that aren't eternal?

Make a list of the things that make you tired and weary. Take a good look at it after you are through, and check off everything on that list that you have given to God through prayer (praying for the situation and letting go), obedience (looking in the Bible for help and guidance), and through counseling with someone (not just getting on the phone with your friend to gossip and complain about the situation, but getting insight from a pastor, pastor's wife, or a solid Christian).

Look at what you have not checked off. Are you trying to deal with things your own way without God? Are you ready to check off the stressful issues? Make it a point to search your heart, and make sure you are truly God's child by accepting him and his plan of salvation for you. Then go back and give your concerns to him through prayer and obedience. Talk to someone about it. Pray for me as I pray for you!

GRIEF

—⟊⟊⟊○

> Though I speak, my grief is not relieved; and if I remain silent, how am I eased.
>
> (Job 16:6)

In the early process of putting this book together, the Lord gave me every chapter title, all at one time. This happened a year before I actually started writing. It was one of those awesome God moments. I had no idea what I would write, or where he would lead in my writing. But let me tell you, it has been an incredible journey of faith and obedience. I am so honored and blessed to be able to share with you just a touch of who God is, and what his love has done for me. This book is not about some new and exciting revelation based on specific theological doctrine. It is about my personal growth and how my life went from total despair and desperation to total reliance and strength in the Father. I am in no way complete, but I do know that I am completed in him.

God has been with me every step in this writing process, giving me peace and comfort. But when he gave me the word *grief* to write about, my first thought was, *Oh my, I really don't*

want to go there. Honestly, I was fearful just at the sound of the word because of what I have been through. I didn't want to revisit old hurts and stir up old emotions. But God in his extraordinary way showed me a new and safe way to look at what I was afraid of.

When we get saved we are not only saved from spending eternity without God, but we are saved from what the prince of this world, Satan, has in store for us. He came to cheat, steal, kill, and destroy. Jesus Christ came to heal, free, restore, and reconcile. Two of the most powerful tools Satan uses in our lives are fear and doubt. He wants us to be afraid to look back and heal from our past, and he wants us to doubt that we can be set free from the ties in which he has bound us.

Satan wants us to have all these strongholds in our life so we cannot be effective for God. Well, here is the truth and nothing but the truth. God's Word is one of the most powerful tools we have to fight off the enemy. Satan is already defeated. He cannot overtake any believer, because of what Christ did on the cross. He will try, but he has absolutely no power over God. You may think the devil is winning the fight over you; but he is not, because you have the Spirit of God living in you. You belong completely to God.

So take whatever gives you fear and doubt and look at it fresh and new through the Word of God. I was afraid to think about the word grief. Just mentioning grieving made me anxious because I have been in total *grief.* I have felt extreme heaviness and enormous sorrow, but along with those feelings I had guilt, shame, anger, and pain. I was there in my grief, without focus on God's Word. I felt as though I was alone without God—but I wasn't. I was living in fear because of my unhealed past, and I doubted I could ever be set free.

It has been through prayer, support, and the illumination of the Word of God by the Holy Spirit that has gotten me through some of the darkest days of my life. I know I will experience

aspects of grief in my life, but I have learned to see why I was fearful. Through the life-giving Word of God, I can turn from my old way of looking at things and apply the truth. For you it may be something totally different, because of what you have been through. I pray you will dust off some of the old fears and look at them through God's Word. Don't be afraid to look back—it will help you move forward. Just take God's hand and trust in him.

> Who among you fears the Lord? Who obeys the voice of his servant? Who walks in darkness and has no light? Let him trust in the name of the Lord. And rely upon his God.
>
> (Ps. 50:10)

SOMETHING TO THINK ABOUT...

What do you need to dust off and look at in a fresh way through the Word of God? Take some personal time to rethink some old mindsets. Where is Satan lying to you? Does he say you will never be healthy again? God's Word says to prosper and be in good health. Does he tell you that you will never find true love? God is love and he loves you and wants the best for you. Does he threaten you will never finish what you started? God says that he will complete that which he started in you. Do you fear your past, present or future? God says you are forgiven and your past is wiped away. God says he knows the thoughts he has toward you, and they are to give you a future and a hope.

So, open the Word of God and begin telling yourself the truth based on who God is. Search the Scriptures for the facts and learn to bring everything to him. Write about your travels through the Word of God and how you will apply his truth to your biggest fears and worries.

THE ROCK

―♨☉

"Now, Lord, look upon their threats, and grant to your ser-
vants that with all boldness they may speak your Word by
stretching out your hand to heal, and that signs and wonders
may be done through the name of your holy servant Jesus."
And when they had prayed, the place where they were as-
sembled together was shaken; and they were all filled with
the Holy Spirit, and they spoke the Word of God with
boldness.

(Acts 4:29-31)

Whom are you serving? I pray you are serving the most high
Jesus Christ, not only as a born-again believer, but as a fellow
Christian who has trusted and leaned on the Word of God and
taken what it says as literal, useable truth. It is amazing what
the Word of God can do. It can move mountains, calm storms,
and shake foundations. It can cut to the very marrow of your
bones, and cause you to turn around and be on the road to
heaven. It can take a starving, malnourished soul and produce
a full, plump child of God. It can heal everything from a cut
off ear to a broken heart. It can bring comfort to a mourning
widow. It can calm a young mother in the midst of her hectic

day. It can be the exact thing a suicidal teenager needs to hear. It is life changing, life altering and life giving. It is the Word of God and it is for you!

God is exceedingly good, and he loves you beyond measure. I know this because I have the Spirit of God in me, and I can speak the truth with boldness! Jesus is the Word. He has set me so free that I can speak with boldness and confidence in him.

At times, I believe, we rob ourselves of supernatural strength by doubting and fearing. We forget, at times, just who we are in him. We deny and reject our God-given identity. We ignore the Word of God, and we sell ourselves short. But, thank God, he is such a good God. He will reach out his limitless hand of mercy and extend just a little more grace. And when we forget to remember our proper place in the kingdom, he extends his mighty and strong hand to give us a little more, and a little more, and a little more.

The Word of God is powerful, yet obtainable. If you haven't accepted Christ Jesus, the Son of God, God in the flesh, and God with us, into your heart by faith, please do it. The Word of God is real. The Word of God is mighty. The Word of God is for you. You are everything and have everything the Bible promises. Now go and speak it with boldness. Be filled with the Holy Spirit as a born-again believer. Pray and ask God to do mighty things in Jesus' name. Assemble together with other believers and expect grand and glorious things to happen.

I pray that your life becomes a living testimony to who God is. I pray that Jesus shines through in all you do. I pray you go through your life with peace. And I pray that Jesus will always be your Rock!

> For who is God, except the Lord? And who is a rock, except our God?
>
> (2 Sam. 22:32)

SOMETHING TO THINK ABOUT...

Jesus is the Rock. He is God in the flesh. He is the Holy Spirit who gives us strength and boldness. We all have the power to overcome, conquer, and defeat that which weakens us and steals our joy. Read the following verses in your Bible; take note of what your God is and lean on him! 2 Samuel 22; Psalm 18:2; 31:2; 40:2; and Matthew 16:13-19. Take notes!

IN THE WILDERNESS

"Do not remember the former things, nor consider the things of old. Behold, I will do a new thing, now it shall spring forth; shall you not know it? I will even make a road in the wilderness and rivers in the desert."

(Isa. 43:18-19)

Imagine a dry and desolate land that has been lying in complete waste with no worth, no life, and no purpose for a very long time. It is an abandoned place with nothing desirable in it—a lonely, neglected, difficult and rugged terrain. At times, this place is cold and dark. It is a place the Bible calls the wilderness.

The Word of God is full of examples of people walking through or experiencing the wilderness, both literally and figuratively. Apparently God uses the wilderness to cause awareness of disobedience, or to encourage a change of direction in one's life. It is a place meant for discomfort, so that God can have full attention. The children of Israel walked forty years in the wilderness, as told in Joshua 5:60. They experienced death in the wilderness instead of going to the Promised Land. But because God is merciful, they eventually found their way out.

You may be experiencing a wilderness time in your life right now. Understand that it is not meant for you to remain there for very long. The Word of God says to press on during those times of trials. And just like the children of Israel, he will provide for your every need. God is great and mighty and true to his Word. Stay strong and keep going, because you will begin to see light at the end of the tunnel. Cling to your road map, the Bible, for there is a time for everything, even wilderness times. Push through the challenging terrain and climb over the obstacles. Crawl on your knees if you have to. You have gotten this far. Even if you decide to turn around and go back out of the wilderness where you felt safe, you still have to go back through where you came, so you may as well keep moving forward.

Even though the Israelites had to go through the wilderness, God still made a way out so that he could deliver, restore and heal them. He made ways where there seemed to be no way, and he can do the same for you right now, exactly where you are. I have gone through some serious wilderness times in my life. In those times God provided for me in ways that, even to this day, I could not explain. He is faithful even when we are not. He will direct you even though you cannot see. And he will provide, even though you do not have enough. So pack light, wear comfortable shoes, follow your leader, and stay on the path.

"Because narrow is the gate and difficult is the way which leads to life, and there are few who find it."

(Matt. 7:14)

SOMETHING TO THINK ABOUT...

What has been the hardest wilderness you have experienced? What are some of the ways God provided for you during the difficult moments? As you look back, take note when it was obvious that God was sustaining you and providing for you. Also, look at your life as a result of that wilderness time. How is it different?

(Keep in mind that God's mercy is new *every day!* He wants you to keep moving forward, getting all your strength from him! So, learn from your times in the wilderness, and continue to move ahead.)

FAITHFUL

~❦~

God is faithful, by whom you were called into the fellowship
of His Son, Jesus Christ our Lord.

(1 Cor. 1:9)

It is good to give thanks to the LORD, and to sing praises to
your name, O Most High; To declare your lovingkindness in
the morning, and your faithfulness every night.

(Ps. 92:1-2)

Isn't it cool how we can call certain things faithful because of our
heavenly Father's example? I call the Bible that I received from
my mother-in-law when I first was saved 'Old Faithful'. This
Bible has been with me through thick and thin. It has been my
lifeline, my study guide, and my road map. I have gone from
spiritual infancy to a spiritual teen-ager with this book. It has
been by my side for many years. This book has been tried and
true. It is probably one of my favorite possessions. In fact, if I
were to go on the television show *Survivor*, this Bible would be
my luxury item! I love this thing. It has no cover, and almost
every page is curled, frayed, taped together or written on. It is
even starting to get a little moldy! But praise God, his words

endure forever. They never go away, change or conform, because God never goes away, changes or conforms. That is why I love 'Old Faithful' so much. It isn't the actual book so much; it is that I got to know my Savior through reading and studying those pages.

I learned that he is Creator, Master, Servant, Comforter, and Peacemaker. From within that beloved book, I learned he is faithful. Sure, I know you can't really love a book. But it is what this book contains, and what I experienced to get where I am now, that I find satisfaction in. I love the blessing of God's Word in my life, and it just so happens this frail instrument made from paper and ink is where I experienced that.

God is faithful. His Word is true. Take your Bible and see it as the instrument he has allowed you to have. Learn to make it a faithful companion. Mark in your Bible. Take it with you wherever you go. Read, use, and grow from it. Most importantly, write its contents on your heart.

We are so blessed to have the written scriptures available to us at any time. We are even more blessed to have the Holy Spirit as our guide to help us understand the Word and live according to his purpose.

God loves us so much, and we learn that from his Word. So, sing altogether with me, "Jesus loves me this I know, for my Bible tells me so!"

Good and upright is the Lord; therefore he teaches sinners in the way.

(Ps. 25:8)

Then he said to her, "Your sins are forgiven." And those who sat at the table with him began to say to themselves, "Who is this who even forgives sins?" Then he said to the woman, "Your faith has saved you. Go in peace."

(Lk. 7:50)

SOMETHING TO THINK ABOUT...

Your Bible is a treasure full of amazing life-changing golden nuggets. Learn to see it as a privilege to have your own copy of God's Word. If you do not have a Bible, I know of a wonderful Bible ministry that gives out free Bibles to anyone who does not have one. Perhaps if you do own a Bible and you feel led to do so, you can contact Freedom Bible Ministry. See how you can help this ministry distribute free Bibles all over the world. Make a list of people you know that may be in need of a Bible, and be on a mission to get the Word of God into their hands.

Freedom Bible Ministry
PO Box 1112
Cape Canaveral, FL 32920
(321) 720-1251
http://fbm.bodybyfaith.com
fbm@bodybyfaith.com

BIBLE STUDY

I will meditate on your precepts, and contemplate your ways. I will delight myself in your statues; I will not forget your word.

(Ps. 119:15-16)

This book of the Law shall not depart from your mouth, but you shall meditate in it day and night, that you may observe to do according to all that is written in it. For then you will make your way prosperous, and then you will have good success.

(Josh. 1:8)

If you instruct the brethren in these things, you will be a good minister of Jesus Christ, nourished in the words of faith and of the good doctrine which you have carefully followed.

(1 Tim. 4:6).

The Word of God is the most valuable possession a person can own. Think about it. When we agree with God, make Jesus Lord and Savior of our life, and receive the Holy Spirit into our hearts, we attain the key that unlocks the vast treasures

written in the inspired Word of God. I believe that a person can receive Christ and never read the Bible due to age, special needs, isolation or location in the world, and still have an abundant life. It happens all the time. However, since you are reading this book, or having it read to you, there are no limitations to your being able to study the Bible.

The Word of God is his message revealed to the world by chosen people who were inspired and led by the Holy Spirit. The scriptures are free of mistakes (inerrant), and the scriptures are not wrong or incorrect on any of its contents (infallible). The essence and character of God's heart is throughout the Word. Your entire life can change by reading and studying this beautiful Book.

The purpose of the Bible is to strengthen you as a believer in your relationship with God through the grace, mercy and love of our Savior, Jesus Christ. The Bible is diverse and immense, yet simple in its message. It tells the journey of a people who need a Redeemer. It maps the history of mankind, charting and plotting times gone by. As a journal, it records the inner struggles we still face today as fallen people. It is a love story for all time, embracing every reader, and it is for every reader. It is the Word of God and it is full of life-changing principles that will permanently transform your life for good.

In the first chapter of Joshua, God told Joshua that meditating on his Word, observing and obeying, and staying strong in God would make his ways prosperous. By being obedient, he would have success in the things of God. In the New Testament, Jesus said in the book of Matthew that we should, above all, seek first the kingdom of God. We do this by spending time alone with our heavenly Father through prayer, worship, and study. In these precious moments with the Creator of the universe, we truly find him. And by finding him, we begin to see for ourselves his mercy and his truths. I pray that you seek him this day and study your Bible!

All Scripture is given by inspiration of God, and is profitable for doctrine, for reproof, for correction, for instruction in righteousness, that the man of God may be complete, thoroughly equipped for every good work.

(2 Tim. 3:16)

SOMETHING TO THINK ABOUT...

Bible Study. If you are not in an actual group study, begin to pray and ask God to lead you to one that teaches his truths. Ask your local evangelical church for a study you can join. There is something about studying with other believers, especially with women.

Make a list below of what you would consider qualifications for a good Bible study.

JUST DO IT!

⌇𝕀𝕃☉

Now may the God of hope fill you with all joy and peace in
believing, that you may abound in hope by the power of the
Holy Spirit.

(Rom. 15:13)

Just believe. You have no idea how that phrase, spoken to me
years ago dramatically changed my life. I was in a deep pit
of despair when I heard the words of Romans 15:13. After
meditating on these words day and night for a season in my life,
I began to come out of my trench, and started to be transformed
by those words.

For months something hadn't felt right in my walk with
the Lord. I kept thinking, *What is wrong with me?* I knew I
was saved, but I wasn't myself. I felt awkward, to put it mildly.
I began to realize that although I did believe in God and had
accepted Jesus as Savior, I still didn't really *believe*.

When we are ready to follow God and ask Jesus to be our
Savior, we pray that he will save us and cause us to be born-again.
Our reliance upon Christ for salvation is our saving belief. We
rely on God to save us from our sins, and ultimately, an eternity

in hell. This belief, if you are already saved, has already occurred. It is amazing how God saves us and makes us a new creation with this level of belief, but we have a part to play in our spiritual growth also. We need to make the effort to fellowship, study, and pray. We also need to commit our full trust in him everyday. This is the *believe* I am speaking of. It is the belief that requires you to fully entrust your life to Christ and his Word and walk in belief everyday.

Many of us fall short in fully trusting Christ daily. When we fall short, we are in a condition to be ensnared by the enemy's lies. The devil wants us to doubt our belief in God. He wants doubt to eventually lead to fear. This is exactly where the enemy wants every believer to be…doubting who we are, and fearing that we cannot be changed. It is a vicious trap he sets for every believer.

But God in his mighty power offers a way out of this entangling cycle. We must commit to studying the Word of God, and bring who Christ is and what he did for us into our lives. When we speak the truth of God's Word, we are allowing the Holy Spirit to reveal what he has placed in us through the study of the scriptures. During this process of speaking and studying, we must begin to stand firm and whole-heartedly believe what is going into our minds and what is coming out of our mouths.

The Word of God is full of life, and when we realize God speaks to us through his Word, we will understand that we must believe. Start by saying you believe in the Word of God. It is amazing just how this simple yet powerful statement can begin to loosen bonds in your life that have trapped you for years. When I began to say I believed in the Word of God, things started to change for me. Eventually my heart began to line up with my mouth. I began to really, honestly believe the Word of God, and I began to believe God had a good plan for my life.

I made a decision to start believing and stop struggling. In the past, I would prepare for the worst in most situations. I would

focus my belief in the wrong direction. But now, when I am tempted to go down that path, I just say, "I can believe for good or I can believe for bad. I choose to believe God because I know he has a good plan for my life." This has given me tremendous freedom to enjoy my relationship with God.

But the Scripture has confined all under sin, that the promise by faith in Jesus Christ might be given to those who believe.

(Gal. 3:22)

SOMETHING TO THINK ABOUT...

Just believe. Write Romans 15:13 on a piece of paper and stick it where you can see it from your bed. Read it before you go to bed at night and when you first open your eyes in the morning. I did this and it dramatically changed my life.

Write a prayer asking God to give you strength as you seek to just believe.

LIFE

Grace and peace be multiplied to you in the knowledge of God and of Jesus our Lord, as his divine power has given to us all things that pertain to life and godliness, through the knowledge of him who called us by glory and virtue, by which have been given to us exceedingly great and precious promises, that through these you may be partakers of the divine nature, having escaped the corruption that is in the world through lust.

(2 Pet. 1:2-4)

Thank God for life. Not only for life that was given at our physical birth, but for life that was given at our spiritual birth. When the egg and sperm meet at conception, the first tiny cell is already full of life and hard at work making and forming his or her little body. This microscopic being is totally equipped for everything it will need to eventually become a fully functioning person.

That is like our spiritual life in Christ. When we make the decision to follow the promptings of the Holy Spirit and become a born-again child of God, we are given everything we need to become a fully functioning Christian. We instantly receive the

Spirit of God, who seals us and completes us in Christ Jesus. But just as that little life-cell goes through the stages of development, we, too, as children of God must go through stages. Some stages will be easy and come naturally, but other stages will be difficult and painful. That is the way God created life to be, both physical and spiritual.

God is the giver of life in every aspect. Our life is precious to him, especially our spiritual life. If you are his child, your life in Christ should be of the utmost importance to you because you have been chosen, called, and set apart to live your life in a way that is glorifying to the Father. You are blessed with the God-given ability to gain the knowledge of who he is. You are a partaker in every single promise that the Bible talks about. Every blessing, every covenant, every ounce of grace and mercy, and every gift is yours through the acceptance of Jesus Christ as Lord and Savior. It is all, in its entirety, there for us.

Our life is safely in his hands and we are the lifelines to his kingdom. Those around you should see your life as a living testimony to who he is. Your words should be full of life. They should bless rather than curse. They should build up rather than tear down. Your actions should be full of life as well. They should glorify him. They should be a reflection of Christ. Both your words and actions should be a way to express your love for the Father, so that your life is enriched and your joy may be full.

So, set your heart and mind on being full of life. Dwell in his presence by meditating on his word. Let the life-giving words minister to your entire being. Let God's Spirit flow freely in your life so that others notice something different and wonderful about you. We have been given a life worth more than all the silver and gold in this world. Now go out and share the wealth.

See, I have set before you today life and good, death and evil, in that I command you today to love the Lord your God, to walk in his ways, and to keep his commandments, his statues, and his judgments, that you may live and multiply; and the Lord your God will bless you in the land which you go to and possess.

(Deut. 30:15-16)

SOMETHING TO THINK ABOUT...

Today, take note of things around you that make you feel alive. Take note of your surroundings. Pay attention to what is in your environment. What do you see when you look around every day? Is it life-giving or life-draining? Do your words sound full of life? Are your media choices (TV, music, magazines, radio stations, books, websites, emails, newspapers, etc.) pure and wholesome? Would you have Jesus spend the day with you? What changes could you make that would make your life more full of *life?*

BAPTISM

—❦◉

Then Jesus came from Galilee to John at the Jordan to be baptized by him. And John tried to prevent him, saying, "I need to be baptized by you, and are you coming to me?" But Jesus answered and said to him, "Permit it to be so now, for thus it is fitting for us to fulfill all righteousness." Then he allowed him.

<div align="right">(Matt. 3:13-15)</div>

Death, burial, and resurrection. Baptism is the representation of a believer's faith in everything that the Lord Jesus Christ came to earth to accomplish. It is an absolute privilege to follow the example and command of Christ and be baptized, just as he was. There is something special about getting into the water, going under, and rising back up. I was recently blessed when my husband baptized our oldest daughter. We were so proud of her. Like our heavenly Father, we, too, were well pleased.

In the third chapter of Matthew, the Bible talks about Jesus' cousin, John the Baptist. John's ministry was to announce the coming of the Messiah. John's message was clear: "Repent, for the kingdom of heaven is at hand." It is fascinating that John

was chosen before his birth to be the one to "make ready a people prepared for the Lord." And when Jesus came to John to be baptized, John was awed and humbled at the sight of Jesus standing there, waiting to be baptized. John's example of humility, honor and obedience is inspiring.

This example of Jesus' obedience to be baptized, and John's humility, is life changing. Jesus did not need to be baptized. He was sinless. He had no need for forgiveness. But he did it as the perfect illustration of "follow me," so that we will do what is required to be sons and daughters of God.

In Jesus' baptism, along with his death and resurrection, all righteousness was fulfilled, and our right standing with God was restored. We can now partake in what Jesus did for us, not only in his burial, but in his resurrection as well. We go under the water as our old wretched selves, and we come up as brand new, reconciled creatures with a fresh start.

If you have been born-again into the family of God, and if you have been baptized, then God is well pleased with you, and all righteousness has been fulfilled in your life. If you have not, then I pray you make the decision to do what Christ has encouraged you to do and be baptized.

"Go therefore and make disciples of all the nations, baptizing them in the name of the Father and of the Son and of the Holy Spirit...."

(Matt. 28:19)

SOMETHING TO THINK ABOUT...

If you have been baptized (other than when you were a baby), how did it change your life? Write your baptism experience.

If you have not been baptized, or were baptized as a baby or small child, then I recommend you do it soon. If you have given your life to Christ, it is such a blessing and privilege to show that you are his by doing exactly what he did in baptism. God will definitely be well pleased.

SMOOTH SAILING

I, therefore, the prisoner of the Lord, beseech you to walk worthy of the calling with which you were called, with all lowliness and gentleness, with longsuffering, bearing with one another in love, endeavoring to keep the unity of the Spirit in the bond of peace.

(Eph. 4:1-3)

Ever wonder what it would be like to wake up totally stress-free, and in perfect peace with yourself and those around you? Have you ever thought of how your life would be without any doubts or fears? Do you think about the relationships you have with others and how you treat them? Have you ever been offended, jealous, worried, anxious, outraged, or stressed out?

God created the human race with the specific purpose to love and fellowship with him. The Bible says that all God created is good, and we are the handiwork of God, created in his image. His gift to us is his image, which enables us to think and make decisions, just as God does. We are able to distinguish between right and wrong—and can choose between the two—thanks to our free will. That is why it is so important to choose what

is right and good. We need to follow the way of God while we can. We must strive to set our sight on him and stay on the track he has set us on, because if we don't, it can cost us our lives. God's ways are always right; his paths are always straight. Our ways and our paths tend to get twisted when we lose our sight or forget our focus.

God has given each of us something specific to do. He has begun a good work in all of us, and has exclusively given us gifts, talents, and unique qualities so that we can reach our goals and see our dreams come to pass, and others can be blessed and inspired.

But the storms of life still come, and like the disciples, we get anxious and worried and wonder why Jesus is asleep. We get stressed out and fearful. We begin to get crabby and rude. We get easily offended, jealous, and outraged. We begin to look toward ourselves and only worry about our own problems. In times like these we need to go to God and strive to walk worthy.

We are on a mission in this world to be a light where there is so much darkness. There will be times when everything will seem to come against you, especially if God has given you a specific task. The enemy does not like it when we further the kingdom of God. He especially doesn't like it when we give God the glory by keeping our cool when the pressure mounts. It is hard to navigate your boat in the rough waters of life, but if you continue on and follow the stream against the current, you will get to the top of the mountain. So, when you feel like giving up, and you see that the storms of life are brewing, stay strong, walk worthy, and don't rock the boat.

He calms the storm, so that its waves are still. Then they are glad because they are quiet; so he guides them to their desired haven.

(Ps. 107:29-30)

SOMETHING TO THINK ABOUT...

What has God specifically called you to do? Take time to be in quiet prayer about what God wants of you. If he has told you to do something, then write it down. How are you doing with your marching orders? Are you living for God, doing what he asks? Or are you just doing "stuff" for him that you feel will please him? Think about your gifts, talents, and callings, and list them below. Are they being used for God? Pray that God will continue to use you where he has you. Pray that you are where you need to be, doing what he has already equipped you to do.

SEVENTY TIMES SEVEN

Then Peter came to him and said, "Lord how often shall my
brother sin against me, and I forgive him? Up to seven times?"
Jesus said to him, "I do not say to you, up to seven times, but
up to seventy times seven."

<div align="right">(Matt. 18:21-22)</div>

Forgiveness is one of the toughest things for me, besides keeping
my mouth quiet about troubling issues. Forgiveness. In Matthew
18:21-22, Jesus makes it sound so easy. But Peter's question
points out our true human nature. He really thought he only had
to forgive his brother seven times! We are just like that. We think
we have to do the minimum to get by. We think Christianity is
just for our own peace.

Well, we need to wake up and see the big picture! We are
Christians, or "little Christs." We are his people, set apart to do
work for his kingdom. We need to act accordingly. We need to
forgive, regardless of what happened. It is a simple word, but
forgiveness can be very difficult. It hurts to be mistreated and
abused. It hurts to be neglected and forgotten. It hurts to be
misled and lied to.

Here is the good news: Jesus experienced all of these situations and more. He was scorned and humiliated. He was incredibly abused and tortured. It is unbearable to think about what he went through. But he endured it, and in the end he forgave. He still loved his abusers. He even died for them!

Thank the Lord, his burden is light. He requires us only to forgive and move on. We are not expected to die for anyone, or even be best friends with those who have mistreated us. We are only expected to forgive them, pray for them, and perhaps even bless them.

Once you begin on your journey to forgiveness, God will lead and direct you to do what is required, so you will be able to live at peace with yourself and those around you. Forgiveness is not easy, but it is worth it. Just ask the Lord. After all, he forgave you too!

"For if you forgive men their trespasses, your heavenly Father will also forgive you. But if you do not forgive men their trespasses, neither will your Father forgive your trespasses."
(Matt. 6:14-15)

SOMETHING TO THINK ABOUT...

Whom do you still need to forgive? Who makes you angry when you think about them? Dig deep today and write down those whom you need to forgive and how you can begin to be a blessing in their lives. If it is still difficult to forgive and bless, then write a heart-felt prayer to God giving him all your hurts and concerns. Continue to pray for the Lord to help you live in total forgiveness. You will be extremely glad you did.

BOLDNESS

Let us therefore come boldly to the throne of grace, that we
may obtain mercy and find grace to help in time of need.
(Heb. 4:16)

It is absolutely amazing that we can go to the very throne of
God through our Savior, Jesus Christ. We have direct access to
our perfect and mighty God. We, as limited and fallen souls,
can go to the great and faultless King of Kings. Not only can
we go straight to him, but also we can *boldly* go, and receive
mercy, and find the grace to help in time of need. We have been
born into this world as sinful and self-centered beings, and *now*
is our time of need.

Go to the Word of God and seek out what it says about you,
a precious born-again child of God. Meditate and dig deep to
find the true meaning of grace. Be bold in your walk with God.
Like David, we need to face the giants in our life, knowing we
have the Almighty God on our side. We need to fearlessly go
to God at all times, and realize that God will always be on our
side, if we are truly his. We need to have total reliance upon the
grace of God and boldly live in it.

Christ suffered an unbelievably violent and graphically grotesque crucifixion. He did it just for us. He willingly gave up his life so we can live ours without punishment through his grace. Boldly go to his awesome, magnificent, faultless, throne and claim the freely given grace that is there. Live your life out loud for Christ, so you can show others how to receive this wonderful grace. Take your every need, no matter what it is, to God, and expect him to do great and powerful things in your life. Don't sell yourself short, now that you are a follower of the greatest leader of all time. Don't deny yourself a life that is rich and full of God's glory. Most of all, *believe* that you can live a complete, satisfying and enjoyable life. So enter his castle, my fellow princess, and bow before our great and mighty Father. He is there waiting with your crown of grace.

> For the Lord is our Judge. The Lord is our Lawgiver. The Lord is our King: He will save us.
>
> (Isa. 33:22)

SOMETHING TO THINK ABOUT...

Make a list of your spiritual needs and boldly ask God through prayer to help you with your every need. Remember, he says, "You have not because you ask not."

JUDGMENT DAY

But why do you judge your brother? Or why do you show contempt for your brother? For we shall all stand before the judgment seat of Christ. For it is written: "As I live, says the Lord, every knee shall bow to me, and every tongue shall confess to God." So then each of us shall give account of himself to God.

(Rom. 14:10-12)

Are you ready for the day when you will stand before the almighty judge? Are you ready to give an account of each thought, word, and deed? Are you ready to explain your every action and decision? The Bible says that every tongue shall confess that Jesus is Lord. Will you confess Jesus is *your* Lord? Or will you deny him? According to the Word, if we deny him, he will deny us. Even of those who cast out demons, prophesied, and performed miracles, if they did not truly have a personal relationship with Christ, he says, "Then I will declare to them, I never knew you; depart from me..."

I cannot imagine what it would be like to be separated from God. That is why it is important to have faith in God through

Jesus Christ. Even those who spend their lives doing work for God, without faith, will not get into heaven. All the good works a person performs, if one does not personally know Jesus, are like filthy rags. Of course, a non-believer giving to the Lord will bless others, but personally knowing him is the key to having eternal life.

Through Jesus and his strength, we will be able to stand before the righteous judge and give an account for our lives. Through Jesus and his strength, we will be able to make the correct decisions for our lives. And through Jesus, when we do fall short and mess up, we will receive the grace to carry on and live a righteous life.

If you are truly his, then it will be Jesus who defends you on that day. It will be his blood God sees instead of your sin. It will be his righteousness that gets judged instead of your past, and it will be his nail-scarred hands there to bail you out. God is a righteous, loving, and fair judge. But he still is a judge who will convict. Therefore, strive to live a life of holiness without blame, and remember all that Jesus did for you. After all, he will be with you always, even on Judgment Day.

"Most assuredly, I say to you, he who hears my word and believes in him who sent me has everlasting life, and shall not come into judgment, but has passed from death into life."
(John 5:24)

SOMETHING TO THINK ABOUT...

Write a prayer of thanks to Christ for taking your place in the judgment seat.

SLEEP

And being in agony, he prayed more earnestly. Then his sweat became like drops of blood falling down to the ground. When he rose up from prayer, and he had come to his disciples, he found them sleeping from sorrow. Then he said to them, "Why do you sleep? Rise and pray, lest you fall into temptation."

(Luke 22:44-46)

We live in an extraordinary time in history. We could easily be the generation that ushers in the second coming of Christ. The signs of the end are upon us. Matthew 24:12-14 says, "...And because lawlessness will abound, the love of many will grow cold. But he who endures to the end shall be saved. And this gospel of the kingdom will be preached in all the world as a witness to all the nations, and then the end will come." This world is becoming increasingly divided. Evil is spreading like wildfire and the gospel of Jesus Christ is reaching to the far corners of the earth. Just turn on the TV and you can see the outpouring of evil in our world. It is unbelievable and absolutely unthinkable, but it is going to get much worse.

In Luke 22, our precious Savior is facing his eternal fate with extreme passion and tremendous emotion. Jesus is in the garden, praying intensely to the Father in deep agony and total distress. This is one of Jesus' most incredible moments, because he is beginning his journey to the blessed cross to dramatically change the course of our future. In his human form, Jesus willingly exchanged his unlimited spiritual state for a limited physical state. He chose to endure to the very end so we could be forgiven and set free.

After his powerful prayer, Jesus went to his disciples. When he came upon them he found them sleeping from sorrow. They had basically cried themselves to sleep instead of praying like Jesus asked. This was a pivotal time in all the history of mankind, and the very men who stuck closer to Jesus than brothers were asleep. As I mentioned before, we could witness Christ's return. This is a time of great suffering and enormous pain for all the earth. Jesus needs us right now. Will you cry yourself to sleep, or will you stay awake and pray?

But the end of all things is at hand; therefore be serious and watchful in your prayers.

(1 Pet. 4:7)

SOMETHING TO THINK ABOUT...

Do you think the end is near? Read Luke 21:5-38 and write your thoughts and feelings.

JUSTIFICATION

Therefore, as through one man's offence judgment came to all men, resulting in condemnation, even so through one Man's righteous act the free gift came to all men, resulting in justification of life.

(Rom. 5:18)

Guilty. We are all guilty—guilty of lying. A lie is a lie, regardless of its color. Guilty of stealing—have you ever taken a reputation, or credit for a job you didn't do? Guilty of murder—the Bible says that the tongue is an unruly evil, full of deadly poison. Guilty of hating God—Jesus says that if we love him, we will keep his commandments. Guilty of sin—the Bible says that we have *all* sinned and fallen short of the glory of God. We are all guilty. Face it, own it, accept it, and admit it.

But wait, my friend. Before you hang your head down in shame and give up, I have some good news to tell you! Jesus saves! Before you were born, he knew you. He carefully formed you with loving detail. He created you with such care, adoration, and tenderness. He looked upon you and called you his creation. You were created for good. He molded you and breathed his

life into you. You have a purpose. You have a calling. You have a hope. You have him.

God's imprint is inside us, and his greatest desire is for us to fellowship with him. Yes, we all have sinned and fallen short of his glory, but Jesus' love is real. He came to take our sin away and reconcile us to his heavenly Father so that we can be acceptable and righteous in his sight.

When you accept all that the cross offers, you become a child of God. You are redeemed from the hand of the enemy. You are forgiven. You are a new creature, and a partaker of his divine nature. Immediately you are delivered from the powers of darkness, and you are kept in safety wherever you go, because you are strong in the Lord and in the power of his might. You are an heir of God, and a joint heir with Jesus. You are blessed with all spiritual blessings. You are an overcomer, and more than a conqueror. You are being transformed by the renewing of your mind; you are walking by faith and not by sight; you are a laborer together with God, and you are the light of the world! You are sanctified, healed, and justified! You are his, and nothing you can do will ever change what you are in him. Face it, own it, and admit it!

> For he says: "In an acceptable time I have heard you, and in the day of salvation I have helped you." Behold, now is the accepted time; behold, now is the day of salvation.
>
> (2 Cor. 6:2)

SOMETHING TO THINK ABOUT...

I am sure, after reading this, you can think of someone who needs to hear what you have just read. Call a friend, talk to a family member, or visit a neighbor, and read them today's devotion. Then write your experience.

CHECK UP!

—⟨⟨⟨◎

But God, who is rich in mercy, because of his great love with which he loved us, even when we were dead in trespasses, made us alive together with Christ (by grace you have been saved).

(Eph. 2:4)

If you are like me, sometimes you need a spiritual check up. I usually need one when things get overwhelming, or when I get tired of waiting for something to happen. On occasion, things don't go my way and I get off track. Either way, that is when doubt and fear begin to creep in. You may experience something different. But regardless of your struggles, you know when it is time to visit the Great Physician.

God is the ultimate healer. He not only has the power to physically heal, but he has the power to emotionally heal as well. You may not realize it, but when you read and meditate upon the Word of God, it unlocks and releases something wonderful in your life. It is like salve applied to a fresh wound. It relieves and comforts. It fights infection and heals. It eases the pain,

especially when the Holy Spirit comes in, applies a bandage, and seals it with a kiss.

I love it when God soothes our pain. He must delight in our childlike dependence upon him to heal our wounds. Even we, as fallen humans, kiss and comfort our little ones when they fall off their bikes while trying to ride with no hands. How much more will our heavenly Father comfort us?

He is so rich in his limitless mercy and his unending love. We cannot begin to describe or define it. When we totally miss the mark, he is there with arms open wide ready to love, forgive, and heal our deepest wounds. If he loved us enough to sacrifice his own Son for our every sin, even the ultimate sin of unbelief before salvation, think of his love for us now as his very own children.

We are alive together with Christ. Do not ever forget that. No matter what we experience through physical, emotional, or spiritual pain, we are under the wonderful grace of God. I pray that if you are in pain, or have a wound that just won't heal, you will make an appointment with the only One who can cure with a dose of plentiful mercy and a prescription of abundant love. This doctor makes house calls and he is always in!

> When Jesus heard that, he said to them, "Those who are well have no need of a physician, but those who are sick. But go and learn what this means: 'I desire mercy and not sacrifice.' For I did not come to call the righteous, but sinners, to repentance."
>
> (Matt. 9:12-13)

Something to think about...

Do you need to make an appointment with our heavenly Father? Do you need some spiritual healing? Write down all your "illnesses" asking God, through prayer and confession, to show you his healing power. Bring it all to him and then step aside and let the good surgeon take care of all your pain.

HARDSHIPS

Though I walk in the midst of trouble, you will receive me; you will stretch out your hand against the wrath of my enemies, and your right hand will save me. The Lord will perfect that which concerns me; your mercy, O Lord endures forever; do not forsake the works of your hands.

(Ps. 138:7-8)

It is so unsettling to see a fellow Christian who has been saddened and depressed by life. I can only imagine how our heavenly Father feels when he sees one of his own children desperate and defeated. Life is tough. For many, life is so unbearable and horrible that they have abandoned all hope of having it any other way.

I can relate to feelings of hopelessness in some ways. I remember thinking God didn't care my water had been cut off, and I didn't have money for food. Reflecting back on my childhood, I've thought that if it had been different, I would be a better person. I understand when someone tells me they have not been out of bed in days. I know what it is like to lose someone you love, and still miss them to this day, so much that it hurts. I understand because I have experienced these

situations, and more. But, most importantly, God understands, because he is with you and has been with you through it all, right by your side.

He is with you now. Just reach out to him, crawl into his infinite lap, and gaze into his eternal face. No one can give comfort and healing like your heavenly Father. He created you. He formed you. He was there at your birth. He was there the first time you felt pain. He was there when you were mistreated and alone. And he was there when you cried out to him to save your soul.

God knows you better than anyone else in this world. Despite your circumstances and your past troubles, he still loves you and recognizes you as the apple of his eye. Listen to that. *He loves you* no matter what. Nothing will change his mind about you. He loves you! When I just sit and think about how much God loves us, it blows me away.

God loves you whether you have been hurt, or you have hurt someone else. He is the God of never-ending chances. We walk a difficult path on this earth. There is nothing written that says life is easy and sorrow free. The word of God doesn't even say that. But it says he will give us comfort in sorrows, help in trouble, strength in weakness, power and might instead of fear and doubt, wisdom when we ask, life in the midst of death, and much, much more. Just cast your cares on him because he definitely cares for you.

> I will be glad and rejoice in your mercy, for you have considered my trouble; you have known my soul in adversities.
>
> (Ps. 31:7)

> "Come to me, all you who labor and are heavy laden, and I will give you rest. Take my yoke upon you and learn from me, for I am gentle and lowly in heart, and you will find rest for your souls. For my yoke is easy and my burden is light."
>
> (Matt. 11:28-30)

SOMETHING TO THINK ABOUT...

Take time today to think about how mighty God really is. He loves you no matter what you are going through, or what you have gone through, or what you will go through. Remember—all things work together for his glory. He has a plan and a purpose. Just rest in him.

Say a special prayer for someone who is going through an extremely difficult time. It could be the death of a friend or family member. It could be the news of cancer or some other disease. Just pray for those you know, or don't know personally, that have a difficult road ahead of them. Write a prayer list and refer back to it periodically.

HAVING IT ALL

—ᴺᴼ⊙

He who did not spare his own Son, but delivered him up for us
all, how shall he not with him also freely give us all things?
(Rom. 8:32)

Have you ever flipped on the television late at night to look
for reruns of your favorite old shows, but instead found
advertisements or infomercials for some product or program
that, according to the announcer, you absolutely must have? It
could be the latest fitness equipment "to shape and tone your
problem areas" (or a place to hang dirty laundry). Perhaps it
could be a wonder pill "to help you lose 30 pounds by Friday"
(or be dead by Monday). Maybe you have seen the "get rich
quick" programs that promise: "You too can make $300,000 a
day for only 12 payments of $39.99 plus shipping and handling"
(the only person who is getting rich quick is the one who came
up with the program).

In today's world, more and more we are being told we too
can "have it all." We can have riches, beauty, fame, a better
body, a great career, more knowledge, a better spouse, a newer
spouse, no spouse, a bigger house, another house, a faster car,

smarter kids, better vacations, whiter teeth, a new face, and a new body. According to the world's standards, if you had access to an unlimited amount of funds, you could literally "have it all." Anything worth something in the world can be attained by money, which, in this world, is your key to happiness and success. Praise God, because with him the opposite is true.

In the Old Testament, the people were promised a Savior. They were expecting a great and powerful ruler who could deliver them from their enemies with the finest of soldiers. Someone with royal gowns and all the pomp and circumstance of a great king who would make his presence known by what he possessed. They were looking for someone who, according to their standards, "had it all." But what they were given was not what they expected. They were presented with a baby, born amongst farm animals, whose parents were unknown in a town where the common folk dwelled. They got a man with no permanent address, who walked the streets with the adulteresses and the thieves. They got a man who talked to children and rode on donkeys. They got a man who was rejected, spit on, and beaten. They got a man who never sinned but was punished so they wouldn't have to be. They got a man who rose from the dead so they could spend eternity with their God. Unknowingly, they got it all; they got JESUS.

But he was not what the world would call someone who "had it all." The very people who he came to set free rejected him because of their own standards, the world's standards. The same thing still holds true today. People think they can somehow buy it "all," and they do not need God. They will not accept what he freely offers. God freely gave his own Son as a sacrifice for our sins so that we can have access to everything the Bible promises us through Jesus Christ: Eternal life, victory over the enemy, forgiveness of sins, access to God at any time, the Holy Spirit for comfort, the Bible for guidance, favor with God, true freedom, pure joy, inner peace, and abundant life. All this and

more is what "having it all" truly means. And all this and more is absolutely free, guaranteed.

> "And she will bring forth a Son, and you will call his name Jesus, for he will save his people from their sins."
>
> (Matt. 1:21)

SOMETHING TO THINK ABOUT...

What do you want? I mean, if you could literally have it all, what would you want? Write down everything you want, no matter what it is.

Look at your list. After you attained everything on your list that you wanted, how would you feel? Do you think you would be satisfied? Would you have that deep sense of fulfillment, or would you still be looking for more? Think about what you really need. Is Jesus enough for you? If not, do you really have him, or are you looking for more?

Remember, Jesus is what you need to "have it all." He is enough. Continue to seek him with all your heart. He is waiting for you to surrender all so that you can truly "have it all."

FRIENDSHIP

"Greater love has no one than this, than to lay down one's
life for his friends."

(John 15:13)

Jesus was sent among us to bridge the gap between man and God
through his death and resurrection. In addition, he was sent here
to be the ultimate example of how to live a life pleasing to God.
Jesus, the Savior of the world, the Prince of Peace, the King of
Kings, came as a common man. He give the impression of being
just like any regular, working class, non-royal man, so that he
could communicate with and minister to the masses.

Through his parables, stories and commands, he reached a
multitude of ordinary, everyday people. With his extraordinary
way of bringing God's life-giving, life-changing principles to
those early believers, he spoke directly to their hearts. He used
simple language that anyone listening could relate to in everyday
life. And he spoke with such authority that even the high priests
and Jewish leaders began to take notice. In other words, when
Jesus spoke, people listened. They either accepted or rejected
what Christ had to say.

The same holds true today. In our precious Bible, those same simple, relatable words that Jesus spoke give people the choice to accept or reject. The Bible is one of the most controversial books in history. It is often taken out of context and misused. However, put the Word in the right hands and it is one of the most amazing and beautiful books, full of life, and dripping with love.

It is funny how we try so hard to dig deep in the Bible to come up with something new and exciting. Sometimes, through the prompting of the Holy Spirit, we can study and apply to our lives something simple that Jesus spoke, and it can bring us great freedom, even change our lives completely.

I love to take common words and compare them with what Jesus says about them. Take the word *friend* as one of these simple, yet wonderfully rich words. In the book of Matthew, Jesus calls himself a friend of tax collectors and sinners. In Mark, Jesus tells a man delivered from demon possession to tell his friends, "What great and mighty things the Lord has done for you." In John, Jesus explains that if we will abide in his love and keep his commandments, we are his friends and he will lay down his life for us.

Jesus is our friend, our true friend. He is everything a perfect friend was meant to be. He is my friend. He is your friend. He is what we should strive to be in our own friendships. Cherish your friends as Jesus cherishes us as friends. If any of your friends do not know Jesus as Lord and Savior, share with your friends who he is and what he has done for them. After all, that is what being a true friend is all about.

A friend loves at all times and a brother is born for adversity.

(Prov. 17:17)

SOMETHING TO THINK ABOUT...

Think of one of your best friends. What is this person like? What impact has their life had on your life? What have you gone through with your friend that has strengthened you? What do you love most about this person? Write about your friend.

LOVE

Beloved, let us love one another, for love is of God; and everyone who loves is born of God and knows God. He who does not love does not know God, for God is love. In this the love of God was manifested toward us, that God has sent his only begotten Son into the world, that we might live through him. In this is love, not that we loved God, but that he loved us and sent his Son to be the propitiation for our sins. Beloved, if God so loved us, we also ought to love one another.

(1 John 4:7-11)

God is love. Isn't that incredible? God is love. That thought alone can set any captive free. That thought alone has set me free, and continues to do so. I often stand in awe that the God of the universe, the God of all creation, and the God of all time is my Father whom I can talk to at any moment. Why? Because he loves me and he gave himself for me through Jesus Christ, his Son.

I matter to God. How I feel, what I think, what I say, what I do. This all is important to God. He feels exactly the same way about you, too. You matter to God. His healing voice speaks so clear to us in the remarkable pages of his Word. He wants the

very best for us. He loves us because he Is love. He can't be any different. My sister, take that in.

When I picture God, I see myself as a hurting and scared child in my loving Father God's arms. He is holding me and comforting me in a way I have never been comforted before. I know many of you did not have an earthly father who was anything near to how I described Father God, but when you begin to give your heart to the One who created it, he will give you a new vision of a loving and comforting father. Accept it because he is love. I pray that you will begin to see yourself as someone who is worth loving, so that you can start to share this incredible love with others. John 3:16 is one of the most quoted verses from the Bible: "For God so loved the world that he gave his only begotten Son, that whoever believes in him should not perish but have everlasting life." God is love, and he loves us, and he loves the world.

We live in a hurting and dying world. There are television channels devoted to covering all the horrible, violent, and sickening tragedies that are happening in our world 24 hours a day. It is so evident that this world needs to know and accept the love that God poured out on us through the cross. Love is throughout the Bible, and is, most definitely, the theme of the entire book.

It was love that allowed Adam and Eve to receive grace and mercy. It was love that provided for the Israelites in the wilderness. It was love that brought us a baby who would grow up to be the Light of the World. That same love kept him nailed to a cross after being severely beaten and abused. It was love that raised him from the dead, so we can have eternal life with the Father. And it is love that allows us to live so wonderfully at peace with God.

God is love. We are his, and he is in those who have believed and accepted the free gift of salvation. Therefore we have the ability to love not only ourselves, but others as well. God has

shown and demonstrated love and it is up to us to be filled with that love so we can give it away. Don't forget that. Others will see the love of Christ you have on the inside and be drawn to the cross. Loving others isn't easy, but once you realize just how much God loves you, despite yourself, you will begin to see that others need that same love. Remember what love is: patient, kind, hopeful, rejoicing in truth, bearing all things, believing all things, enduring all things. Love is not envious or full of pride. Love is not rude, selfish or evil. Love doesn't even think of evil or sinful things. God is love! He can't be anything else but loving. So surround yourself in that love, remember what love is and isn't, and freely give it away. I love you!

"As the Father loved me, I also have loved you; abide in my love. If you keep my commandments, you will abide in my love, just as I have kept my Father's commandments and abide in his love. These things I have spoken to you, that my joy may remain in you and that your joy may be full. This is my commandment, that you love one another as I have loved you."

(John 15:9-12)

SOMETHING TO THINK ABOUT...

God loves you. Just think about that and remind yourself all day that God loves you. There is nothing you can do to make God stop loving you, no matter what you have done or what you will do. He loves you! Accept his love with all your heart. Even if you have not yet given your life to Christ (you will soon!), he still loves you. So deal with it. GOD LOVES YOU!

In the space provided, write a love letter to God.

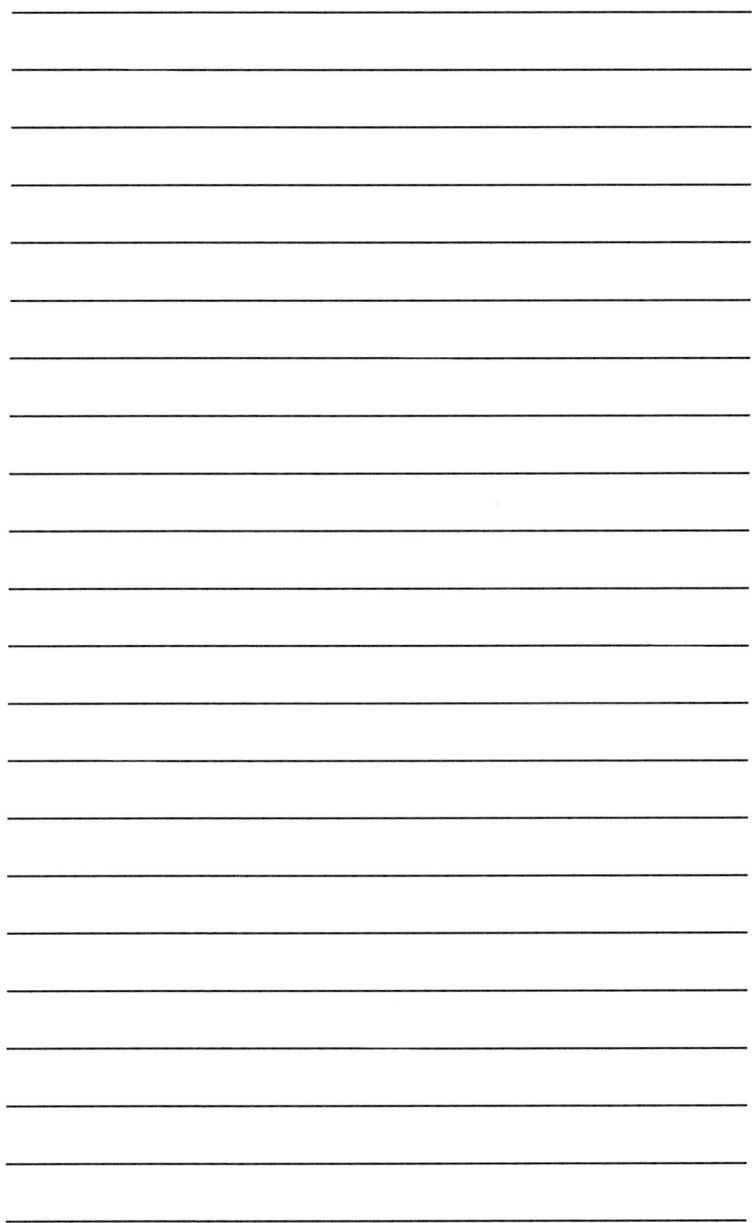

To order additional copies of

GOOD MORNING
Beautiful

A 40 DAY DEVOTIONAL JOURNAL

Have your credit card ready and call:

1-877-421-READ (7323)

or please visit our web site at
www.pleasantword.com

Also available at:
www.amazon.com
and
www.barnesandnoble.com

Printed in the United States
52620LVS00002B/46-144